IMAGES
of America

LEAD-MINING TOWNS OF
SOUTHWEST WISCONSIN

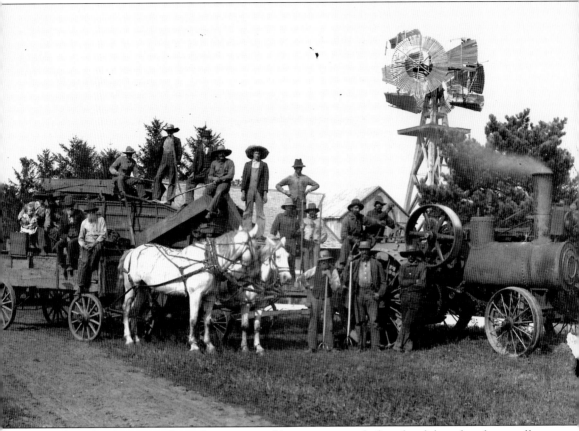

When threshers arrived at a farm, men and horses were ready for a hard day of work, as well as some fun and laughter. The woman of the house had also been working since daybreak preparing the noon meal. She would have enlisted the help of neighbors and female relatives who appeared after their own chores were done to peel and chop vegetables or bake pies and bread. Girls carried water form the well, poured it into a tub to warm in the sun, and brought a supply of towels. They also prepared long tables to accommodate up to 20 men. (Courtesy of Rena Mullen Amacher.)

On the cover: The village of Cottonwood was settled around the Frontier Mine near Swindler's Ridge. The town was later named Benton, to honor U.S. congressman Thomas Hart Benton, who was an advocate for miners. Here, an unidentified couple walks their dog. (Courtesy of Badger Mine Museum.)

IMAGES of America
LEAD-MINING TOWNS OF SOUTHWEST WISCONSIN

Carol March McLernon

Copyright © 2008 by Carol March McLernon
ISBN 978-0-7385-5199-9

Published by Arcadia Publishing
Charleston SC, Chicago IL, Portsmouth NH, San Francisco CA

Printed in the United States of America

Library of Congress Catalog Card Number: 2007940132

For all general information contact Arcadia Publishing at:
Telephone 843-853-2070
Fax 843-853-0044
E-mail sales@arcadiapublishing.com
For customer service and orders:
Toll-Free 1-888-313-2665

Visit us on the Internet at www.arcadiapublishing.com

Contents

Acknowledgments — 6

Introduction — 7

1. Three Mounds and the Point of Beginning — 9

2. Natchez, New Digs, and Strawbridge — 21

3. Cottonwood — 43

4. Shullsburg — 51

5. Farms and Small Towns — 81

6. Cuba City and Darlington — 111

ACKNOWLEDGMENTS

Many persons gave generously of their time and expertise in making this book possible. A few of the computer experts were Steven Follett, David Schupbach, and Scott Schupbach. Some of the knowledgeable historians were Pauline Alexander, Rena Mullen Amacher, Harold and Geneva Beals, Wayne and Eleanor Bennett, William and Priscilla Edge, George Burns, Nathan and Donna Garwell, Maxine Ryan Hess, Marion Howard, James Knox, Norene Pfeil, Beverly Stabenaw, Dan and Angie Dickinson Schmidt, William and Rebecca Wetter, James Fitzpatrick, and Brenda Ray. Except where noted, the images are from the author's collection.

Introduction

The Sauk and Fox tribes, living in wigwams among the rolling hills between the Rock and Mississippi Rivers, were farmers. They had little use for the lead, which was abundant, even lying on the ground. When white men arrived on the scene, the natives were able to use lead for bartering. White men used it to make, among other things, bullets.

Black Sparrow Hawk was born in Canada in the late 1800s. Although he was not considered a chief, he became a respected war leader and touched the quill to the treaty paper that ceded this region to the U.S. government in 1827.

Later Black Hawk indicated that he did not know he was giving away his gardens, claiming the chiefs' inability to read the English words on the paper and that white men had given whiskey to them before the signing. Nevertheless the Treaty of 1827 allowed for the natives to remain at their village called Sauakunauk, present-day Rock Island, Illinois, until the lands were sold. And soon enough, the lands were sold to settlers, mostly from the south and the east. Black Hawk, realizing his tribal members would starve if they could not harvest their crops, returned from Iowa Territory with about 800 of his people—women and children along with several hundred warriors—in an attempt to regain their property. After initial hostilities, it is believed that the natives tried three times to surrender, but soldiers, along with their Sioux and other Native American allies, tracked and killed many of them.

The war cost 250 lives and $2 million and opened up the region to mass settlement. Among the first white men to settle permanently in the area were Col. George Davenport, Julien Dubuque, Jesse Shull, John W. Blackstone, William Hamilton, George Ferguson, Charles Gear, Amni Dodge, Ahab Bean, James and Dennis Murphy, and the Gratiot brothers, Henry and Beon. Their settlements included Buncombe, Horseshoe Bend, and White Oak Springs—first of the lead-mining towns of southwest Wisconsin.

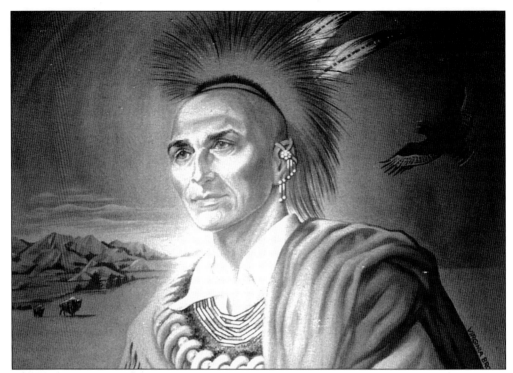

The grave expression of Black Sparrow Hawk was captured by Virginia Broderick, a Milwaukee artist. She attended the Layton School of Art, Mundelein College, and the Art Institute of Chicago. Much of her work has been displayed in churches across the globe. (Courtesy Irving Young Memorial Library.)

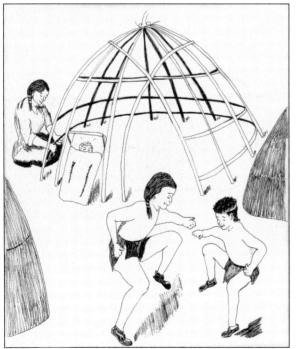

Native Americans who lived in this area were previously referred to as Woodland Indians. They lived in wigwams, which were easily dismantled and moved to seasonal homes. They planted and harvested much of their food. They had little use for lead which could be found lying on the ground.

One

THREE MOUNDS AND THE POINT OF BEGINNING

Three mounds rise above the surrounding terrain east of the Mississippi River. From certain high places, like Council Hill and Signal Hill all three mounds were visible. Surveyors Lucius Lyon and John Rountree worked during the Black Hawk Uprising of 1832 to establish the Point of Beginning, where the rolling hills to the north blended into the flat lands of Illinois. It was near Sinsinawa Mound. According to the historical marker at the site, "Every section corner monument . . . county, city . . . all were surveyed and mapped from this Point of Beginning."

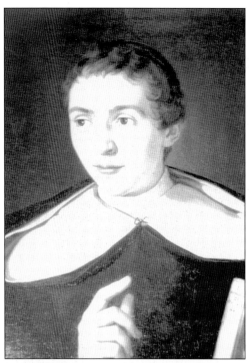

When white settlers began arriving in the "Land of Gray Gold" after the Black Hawk War, Fr. Samuel Mazzuchelli was among them. He had traveled along waterways from the Green Bay area to design churches, raise funds, and preach wherever he could. His mission included 300 miles of land on both sides of the Mississippi River. His headquarters were in Galena but he spent much of his time traveling. Fun-loving Irish miners called him Fr. Mathew Kelly.

The Native American name for Sinsinawa Mound was Home of the Young Eagle. They considered it a holy place. U.S. representative George Wallace Jones lived in a log cabin on Sinsinawa Mound. When it became necessary for Jones to move away, he sold 800 acres, which included the mound, to the priest for $6,500.

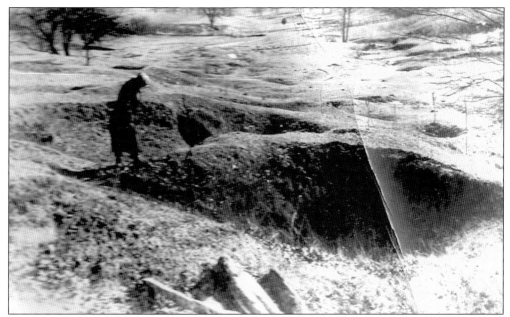

Many of the men who moved into the lead-mining area divided their time between mining and farming. Digs like these were called sucker holes. It was believed that the miners who went south for the winter were like suckers, fish that migrate. Another likely theory might be that farmers considered prospectors foolish for wasting their time when they could have used the rich soil to grow crops instead. (Courtesy of Badger Mine Museum.)

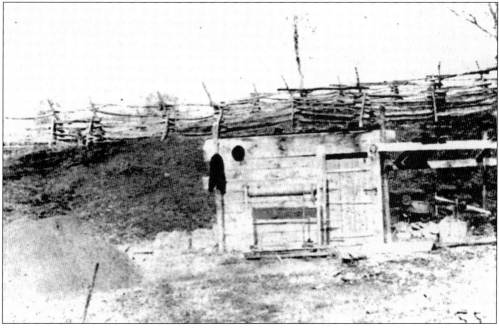

When news of the newly discovered riches reached the outside world, a rush followed. Miners were so busy looking for ore they did not have time to build suitable homes for themselves. They dug caves like this in their search for the gray gold. Sleeping in the caves gave them the nickname of "badgers." (Courtesy of Badger Mine Museum.)

Fr. Samuel Mazzuchelli, or "Father Kelly," established Catholic parishes along both sides of the Mississippi River, from Prairie du Chien to Burlington, Iowa. He was responsible for building churches in two of Iowa's capital cities. His most ambitious project was a huge academy on Sinsinawa Mound. The three-story building nestled among the trees on the south side of the mound. He planned for housing of students and faculty and made use of the fort and George Jones's farm buildings. Using mission money, he bought the finest furnishings available, including a piano, which was delivered on an ox cart. Communion wine was made from grapes grown on the property.

Father Kelly kept George Wallace Jones's fort (shown here) but there was nothing in the priest's memoirs that would indicate that he ever had a trace of fear of Native Americans. He had worked and lived with tribes around Green Bay and Portage for a number of years before assuming the mission along the Mississippi River.

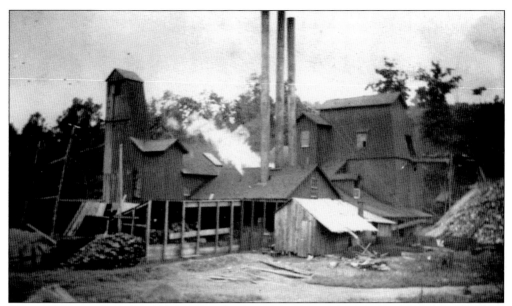

The settlement of Hardscrabble was not far from Sinsinawa. The name, which means fistfight, was changed to Hazel Green. Three big mines were in operation to the south of Hazel Green in the early 1900s. The Kennedy Mine, pictured here, was used by New Jersey Zinc Company and included the Hoskins Mine and an incline from the Bull Branch. The New Deal Mine and Big Dad Mine were also nearby. Vinegar Hill Zinc Company operated the Crawford Mine around 1900. (Courtesy of Badger Mine Museum.)

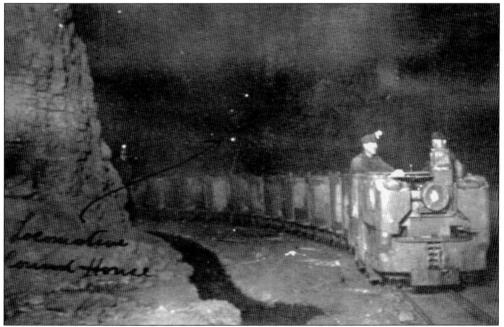

The Laurence Mine was discovered near Hazel Green by the Cleveland Mining Company in 1913 and continued in operation until 1917. It boasted a locomotive roundhouse. As with many mines, excess water became a serious problem. The mine was abandoned after a flood of the Scrabble Creek completely filled it with water. (Courtesy of Badger Mine Museum.)

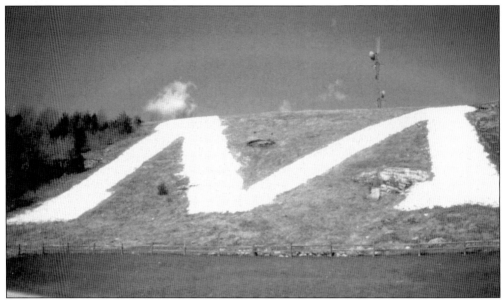

The Mining School was established in 1837 and became part of the university in the 1960s. Tons of rocks were used to create a letter M on the side of Platteville Mound. Engineering students have continued the tradition of relaying a torch to light the M every year. Native Americans had a smelting process for lead ore. They shaped ore into brick-shaped "plattes." The settlement that grew near the second mound, about 15 miles north of the Point of Beginning, was called Platteville. John Rountree settled there.

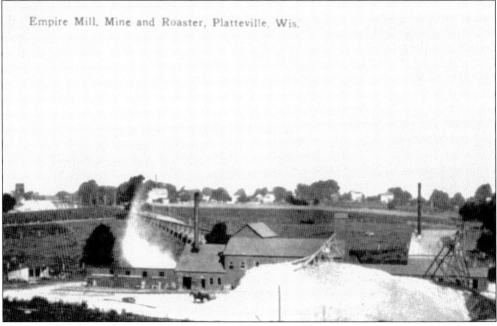

Mines in the Platteville area included the Empire Mine and Roaster. As a mine grew, it became necessary to have a smelter or roaster nearby. A mine could soon produce a large pile of rocks which could be further processed to produce more lead. After some time, the rocks turned a rusty red color. (Courtesy of Badger Mine Museum.)

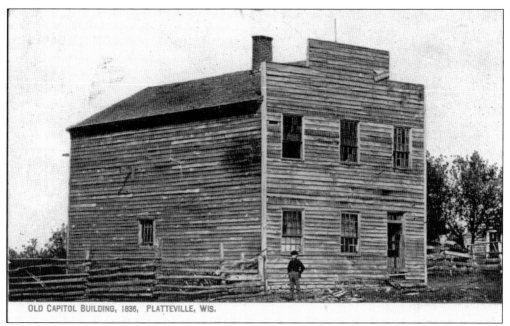

OLD CAPITOL BUILDING, 1836, PLATTEVILLE, WIS.

The third mound was east of the other two and not quite so tall. Fr. Samuel Mazzuchelli served as chaplain of the first territorial meetings at the base of the mound in 1836. Politicians Gen. Henry Dodge and James Doty attended, as well as U.S. representative George Jones. It was at these meetings that the decision was made to have the permanent capital for the territory at Four Lakes, later named Madison, for the president. Pictured here is the old capitol building near Belmont Mound.

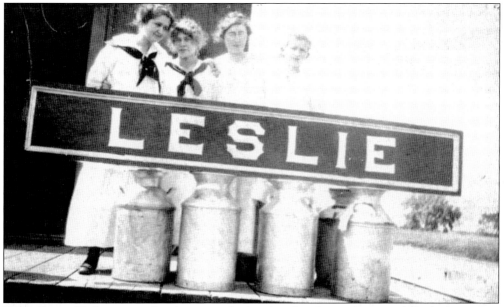

The village of Belmont was first known as Leslie. A railroad soon connected the little town to other mining communities transporting ore to market. A fence was built around a livestock yard so farmers' cattle could be kept there until the next train came. It became the most important location for shipping cattle.

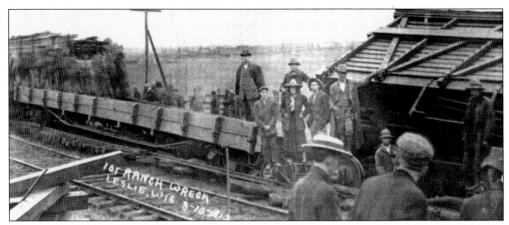

Trains ran safely on the tracks connecting the towns for many years. A train wreck at Leslie, however, caused rail service to be delayed for several days while crews worked to clean up the wreckage. (Courtesy Badger Mine Museum.)

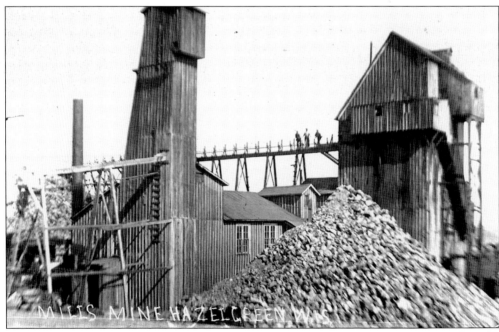

Mills Mine was located north of Hazel Green. In 1912, the three mines were purchased by the New Jersey Zinc Company and operated under the name of the Kennedy Mine. Until 1919, the Mills Mine section was considered one of the richest lead deposits in the region, and it was mined continuously from 1851 until 1919. The grizzly was the sloping part of the mine where men sorted rocks according to size. (Courtesy Badger Mine Museum.)

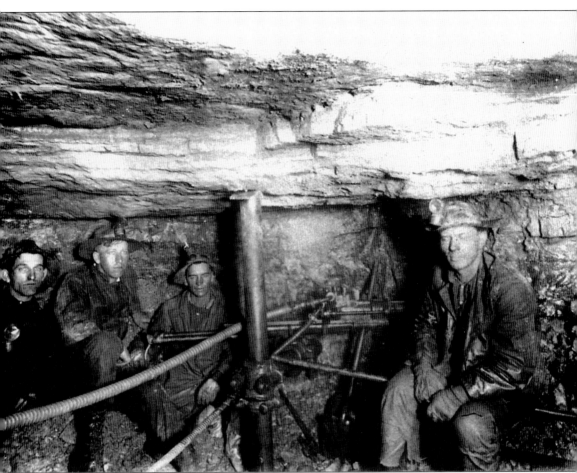

It was close quarters underground. Sometimes there was more headroom, but these men would not have been able to stand up. Notice the support post. Early miners used candles so they could see into the darkness of the mine. Later lanterns were installed on their hats. Two men worked together with picks, sledge hammers, and gads. One held the long-handled gad so the other could hit it to make a place to set the blasting powder. Some men, called blasters, were the brave ones who specialized in setting the charges to loosen and separate rocks. The introduction of dynamite, around the beginning of the 20th century, made their jobs much safer, but men always had to be careful working in mines. (Courtesy of Badger Mine Museum.)

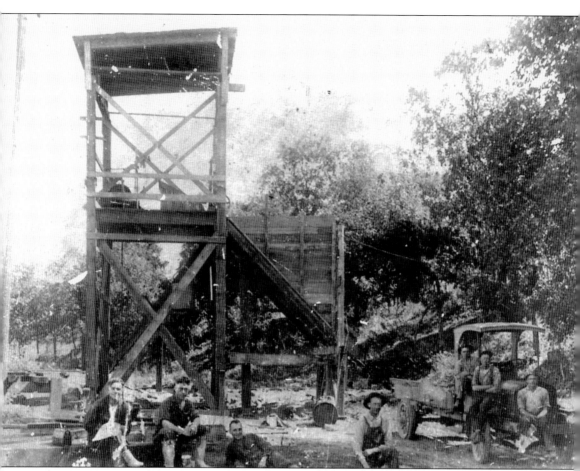

At what point a dig became a mine is an interesting question. If it required some wooden buildings, this may qualify for a mine. Two of the Bale brothers were killed and another man blinded by the blasting. It was said to have been a mine but more likely, they were prospecting supposedly near one of the two Longhorn mines. (Courtesy of Badger Mine Museum.)

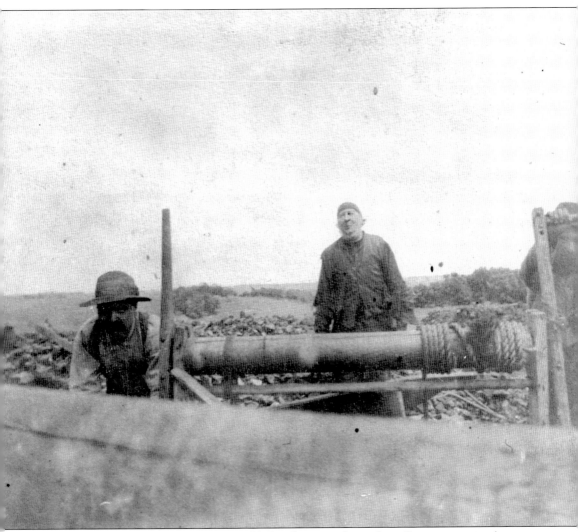

A windlass was used to bring a bucket filled with ore to the surface. Sometimes using horse or oxen for power they were able to work faster. In those early days, everything was done by hand with rather primitive tools. The one at Shullsburg was called the Old Bull Pump. (Courtesy Badger Mine Museum.)

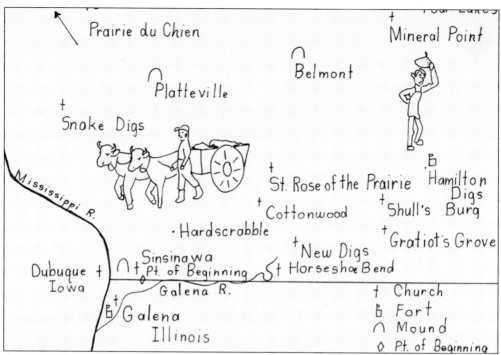

A map of the southwestern corner of Wisconsin shows the Point of Beginning and the three mounds. Mines often took the name of the landowner, like Hamilton Digs. Sometimes, they had names like Snake Digs because caves around the town, which became Potosi, were infested with snakes. Mine owners hired men to get rid of the snakes. The Swindlers' Ridge must have had an interesting origin. And who knows how many fistfights there may have been at Hardscrabble.

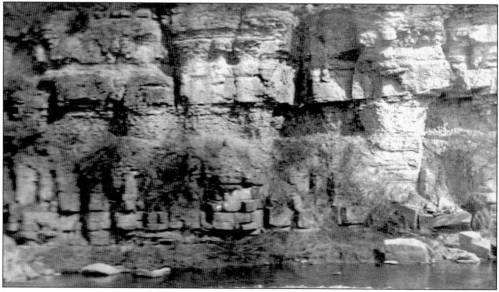

Limestone outcroppings were common among the rolling hills of southwestern Wisconsin. Road crews in the early days made cuts to eliminate sharp inclines. Newcomers into the area were reminded of the geological history and might have considered these cuts gateways to the "Land of Gray Gold."

Two
Natchez, New Digs, and Strawbridge

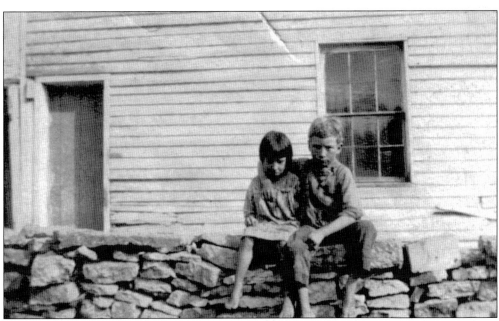

In 1824, new "digs" were discovered by white men at Natchez. The settlement which sprang up on the banks of the Galena, or Fever River, reached 100 settlers by 1828. James Harker purchased the property and later sold it to David Fawcett who farmed the land. Two of Fawcett's grandchildren are shown on the free-standing rock wall made by skilled masons from the British Isles.

This two-story house was built along the river in the mid-1800s. When it was razed in the 1940s, it was discovered that it had been built around a log cabin. A new house, shown in the background, was built and Fawcett family members lived there until the late 1900s. The rock wall was still intact at that time.

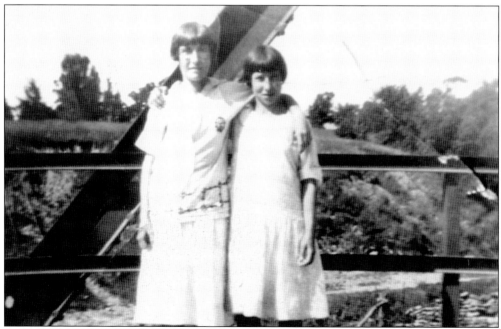

Roads emerged as people, horses, oxen, and wagons traveled through prairie grass and around swampy, hilly, or wooded areas. Early residents hurriedly built crude bridges to accommodate the heavy traffic of early mining and farming endeavors. Bridges consisted of wooden planks set on rocks. Remnants of an old bridge are visible behind Harriet and Ramona Fawcett in the 1920s.

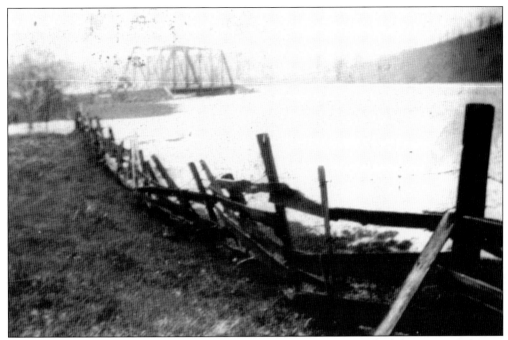

The Fever River often overflowed its banks. Water sometimes even reached the pasture fence not far from the rock wall around the house at Natchez. Rushing floodwater took fences out so after a flood like this, it was necessary for farmers to repair their floodgates so cattle would not get out.

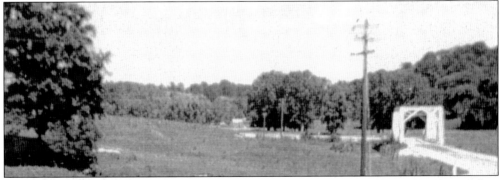

Ore wagons did not attempt to cross the Fever River. In 1917, about the same time the spur line came through, a sturdy bridge was built. The strong girders were set in concrete, which was still intact when the new road was laid in the late 1990s. On the west side of this bridge was the Jack of Diamonds Mine and opposite was the Champion Mine. As indicated by its name, a man won the mine by holding the winning jack of diamonds in a card game. It was destined to become a large producer of ore.

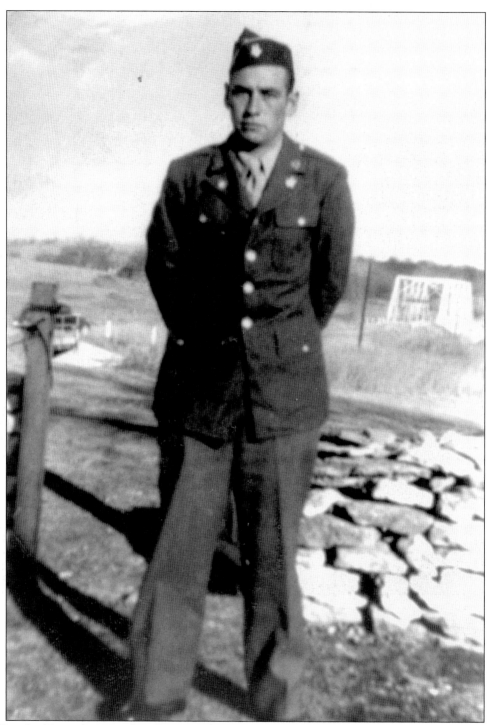

Douglas Temperley, served in Germany during World War II. While he was home on leave, he posed by the rock wall with the bridge in the background. By that time, it was one of several bridges used in transporting supplies and workers over the Fever River and the New Diggings Branch. Government subsidies caused increases in mine production during the war.

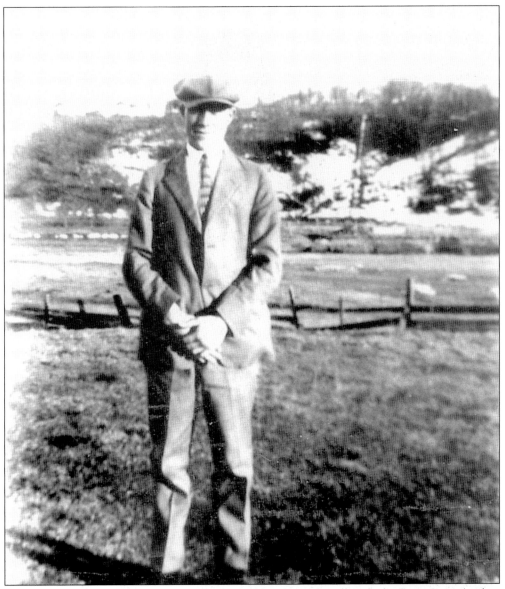
A neighbor of the Fawcett family poses not far from the rock wall with the Fever River (within its banks) in the background. Champion Mine buildings can be seen on the ridge behind him. The tall straight object in the background was a conduit, which was used to pump water from the Fever River to the mine.

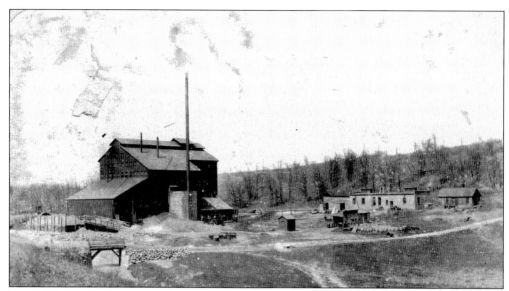

Robert Champion, from Alabama, discovered ore on his property in 1827. His mine became one of the largest producers in the area. Ore was hauled to Benton, Strawbridge, and 20 miles away to Scales Mound by horse or oxen teams. Wagons often became stuck up to the hubs in the mud requiring two or three good teams to pull them out. The road to Benton was among the first to be covered with mine tailings. (Courtesy Badger Mine Museum.)

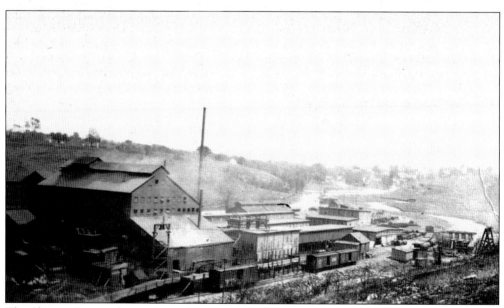

The Skinner Roaster began its work on June 17, 1917. A cable system carried ore between the mine and the roaster. Zinc ore was heated to remove sulphur and other impurities in the roasting or smelting process. Production decreased after World War I so the roaster was dismantled and parts were shipped out of the region. (Courtesy Badger Mine Museum.)

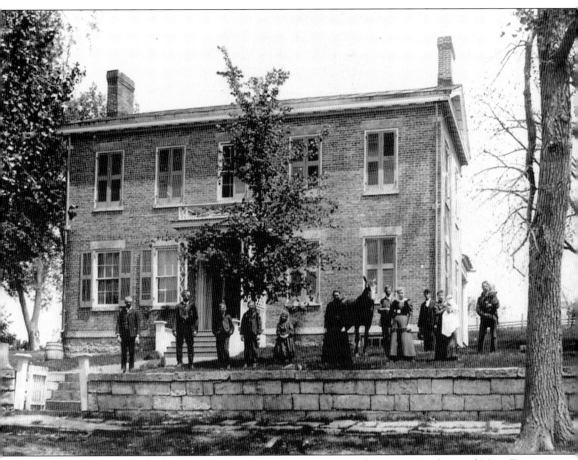

The Champion family lived in the brick house on the curve between Natchez and New Digs until their daughter married. The newlyweds lived there for a while, then it was used as a clubhouse for the mine workers. Behind the house was a large complex of stables and dormitories for workers. The house was granted to Morgan Frazier after he lost his arms in a mine accident. (Courtesy William and Priscilla Edge.)

John Rountree was listed as a member of the Olive Branch Lodge No. 6, which was chartered January 10, 1845. The town of New Diggings was growing so fast in the early 1900s that the Masonic temple was used as a residence. Two of Edward and Alice March's children were born there. The temple fell into disrepair but was later renovated and moved to the cemetery. (Courtesy William and Priscilla Edge.)

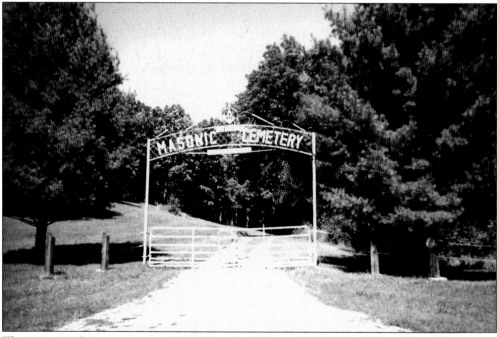

The Masonic Cemetery was established on land donated by Robert Champion, mine owner, and is the only Masonic cemetery in the state. Simon Oliver, Jefferson Duncan (1846), S. M. Conway (1848), and Ephraim Ogden (1862) were among the first persons to be buried there. Judge John W. Blackstone, who lived for many years in White Oak Springs, was buried in this cemetery. (Courtesy William and Priscilla Edge.)

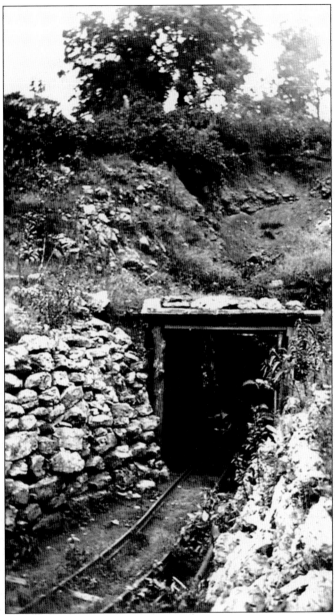

Because of increased lead production, a railroad spur line was needed for the Champion Mine in 1914. A tunnel, approximately one mile long, was dug to connect Natchez to the property of John Strawbridge. The engine ran backward through the tunnel to the Skinner Roaster. The railroad then connected Galena, Council Hill, Benton, Cuba City, Elmo, and Platteville exchanging ore, news, supplies, and culture. Strawbridge Tunnel was put into use during the World War I zinc boom. Chicago and Northwestern trains ran along Coon Branch and the Fever River. The railroad maintained a small station at the entrance of the tunnel which was nothing more than a mounted boxcar. The tunnel allowed for transportation for people who wanted to shop for a few hours in Benton or Cuba City. Sometimes it was necessary to use the train to visit the dentist or doctor. Students at the normal school in Platteville rode home once a week on the train. (Courtesy of Harold Beals.)

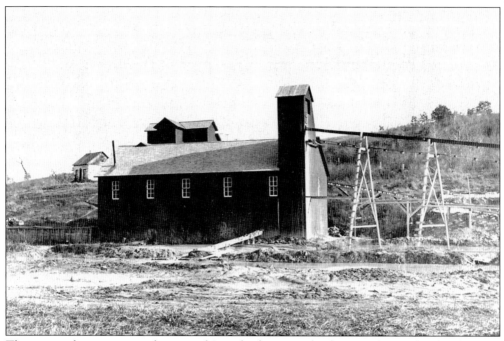

There were three mines in the area of Strawbridge Tunnel. The Strawberry Blonde Mine was on a hill near the tunnel, Rowley Mine was to the south, and Fox Mine was over the hill to the west. The rail section through Buncombe, between Benton and Galena, ended in the late 1930s. (Courtesy Badger Mine Museum.)

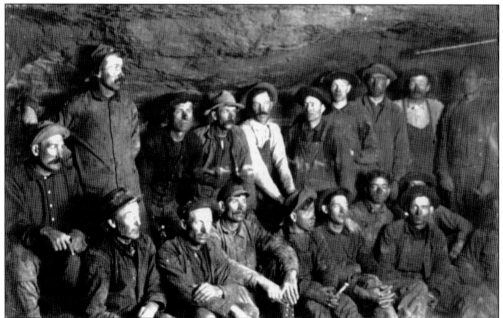

This group of workers, probably at the Champion Mine, posed in their dirty clothes for this picture about 1900. The only miner who was identified when the picture was found recently was Eddie March, probably because he was the youngest man there. He is the fourth miner from the left in the first row, with his hat turned up. (Courtesy Rena Mullen Amacher.)

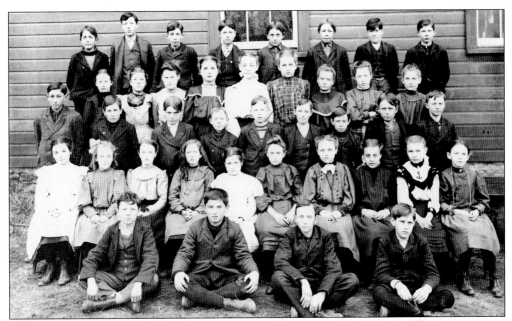

As evidence of the growing community, there are 40 children in the class. Just after the dawn of the 20th century, lead and zinc production were up and prices were good. Miners brought their families to the small towns like New Diggings in the "Land of Gray Gold." Living in modest homes, the children were clean and well dressed. (Courtesy Rena Mullen Amacher.)

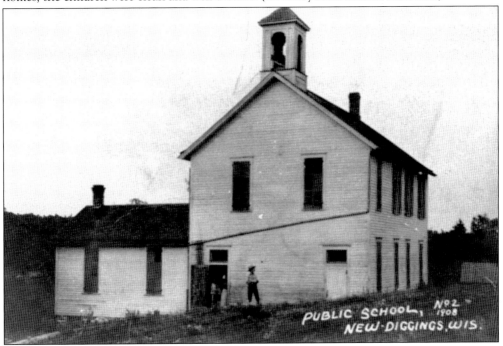

The first school was built in 1874. Classes had been held in Solomon Oliver's home prior to that time. The two-room building was struck by lightning in 1896 and replaced with this two-story building, which cost $2,300 and consisted of the primary and grammar school. Steep wooden steps allowed access from Prospect Avenue. (Courtesy Rena Mullen Amacher.)

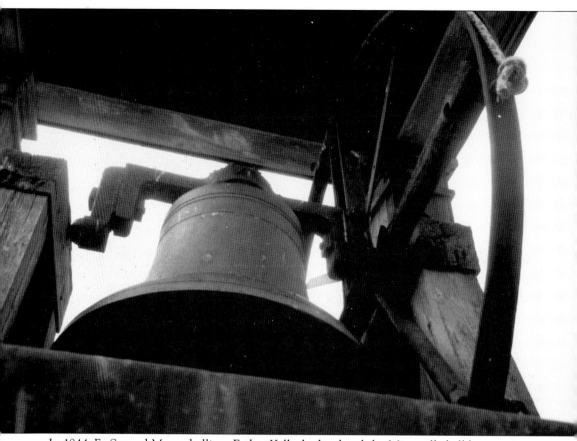

In 1844, Fr. Samuel Mazzuchelli, or Father Kelly, had ordered the Minneally bell because it was the best available. It had traveled from Troy, New York, to Galena. It was delivered from Galena on an ox cart pulled by five teams of oxen. Father Kelly taught classes in the basement of this church one winter. (Courtesy George Burns.)

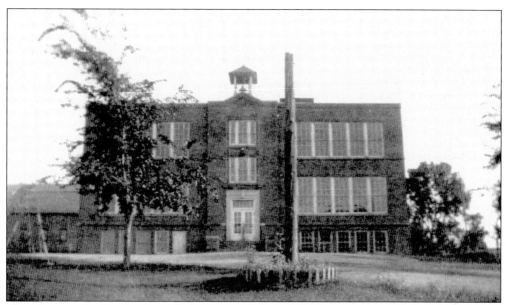

The two-story brick school was built on top of the hill adjacent to St. Augustine's Church in 1919. In 1924, it boasted a 16-member football team. Among the players were Charles Poppa, Donald Monroe, and Ervin March. (Courtesy Rena Mullen Amacher)

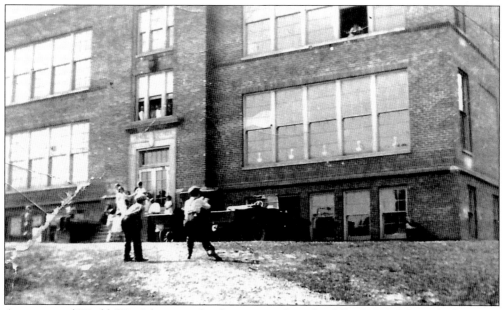

A veteran of World War I became the first principal in the fall of 1919. Through the 1930s and 1940s, students were involved in a variety of activities, including the class play. Because of declining enrollments, the high school was closed in 1952. (Courtesy Rena Mullen Amacher.)

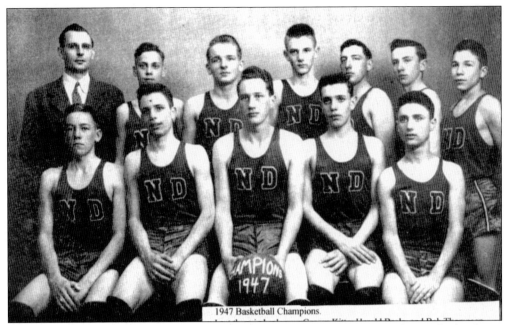

1947 Basketball Champions.

Charles Lacke was the principal as well as the basketball coach in 1947 when the small school won the state basketball championship. Members of the team are, from left to right, (first row) Thomas Bennett, Charles Stevens, Eugene Redfern, William Mauk, and Donald Rock; (second row) Dean Dare, Ronald Poppa, Lawrence Lutes, George Kitto, Harold Beals, and Robert Thompson.

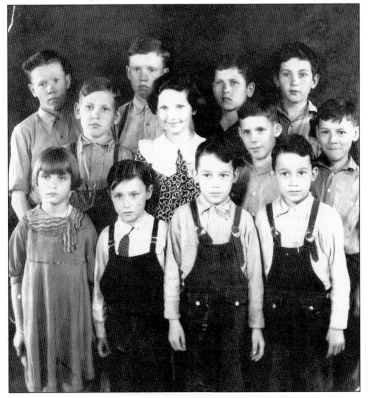

There were several sets of twins attending New Diggings School in the 1920s. Seen here, from left to right, are (first row) Delores and Donald Rock, and the Dunhoff twins; (second row) Ivan and Betty Bennett, and William and Robert Robbins; (third row) Dale and Delmar March, and George and Gerald Redfern. A few years later, Robert and Roberta as well as Dean and Jean Dare could have been included.

The teacher, Eleanor Bennett, has arranged the Race Track schoolchildren to have a picture taken. They are Nancy, Judy, and Harold March; Arnold, Earl, Harold and Charles Leifker; Donald, Richard, Judy, and Joan Temperly; Magelyn and Bonnie Richardson; David and Linda Studier; and Kay Russell.

Ramona Fawcett taught at Race Track School. Her sister Harriet, shown here, taught at White Oak School east of New Diggings in 1929. Sarah Burke and her sister Florence Swanson were teaching in the county at the same time. Harriet and Florence graduated from the normal school in Platteville together. Both continued to live in White Oak Springs.

Led by David Schupbach, these modern-day reenactors prepare to enter a school much like Race Track School. Kristi Schupbach and Derek Gates follow trying to appear like children who would have attended a rural school in the early 20th century. The steps of Race Track went up the side of the facade instead of approaching from the road as these do.

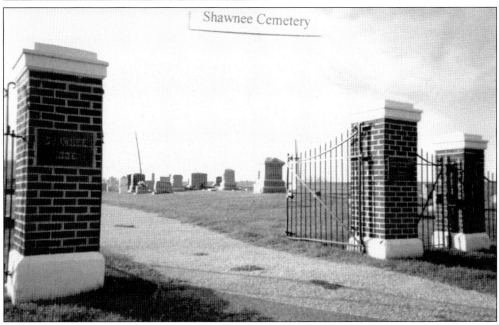

Shawnee Cemetery was so named because local historians relate that at least one Native American was buried there. Among the early settlers who were buried there is Joseph Thompson, who had lived nearby. The cemetery took a corner from the farm that has been the Edge farm for over a century.

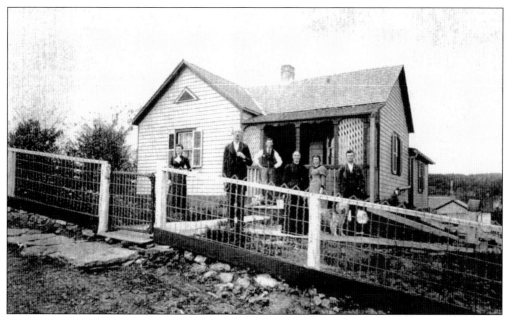

The Burns family lived on High Street in the early 1900s. The parents were Austin and Philomena. Their children include a set of twins and two daughters; Roseann and Loretta. In the background, the top of the coworkers hall is visible. It was built by members of the Presbyterian Church, used by many organizations, and deeded to the Primitive Methodist Church, which used it for many years. (Courtesy George Burns)

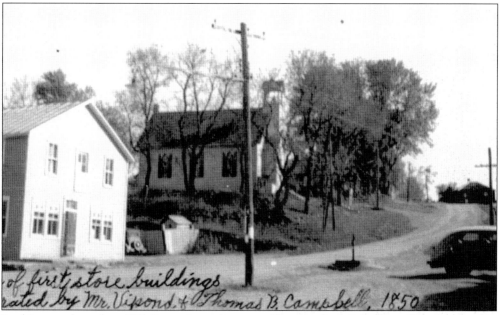

Looking southward up Hill Street from the post office, on the left is Vipond's store, the first one in New Diggings. In the center of the picture is the town pump. The church is the second building the Primitive Methodist congregation used for worship. The first one was a small stone building on the ridge. The newer building was in continuous use for 100 years. (Courtesy William and Priscilla Edge.)

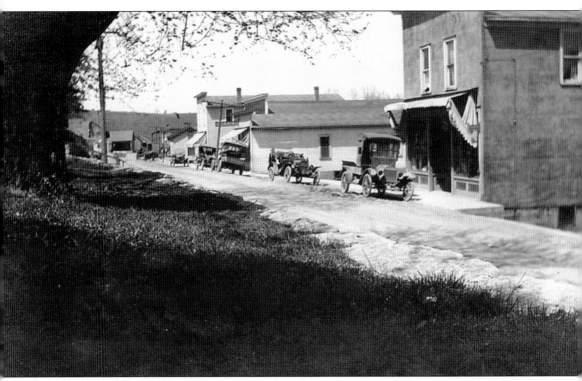

Prospect Avenue was the main street of New Diggings, as it was called. It ran along the New Diggings Branch with a hill on either side. The George Watson family lived in the basement and operated a general store. Other businesses on the north side of the street in the 1940s included two hotels, Vickers' Barber Shop, a theater, a restaurant, and Lucy Carter Simons' Store. The Farmers and Miners Bank was located on the south side and the post office faces east at the end of this street scene.

Samuel Vickers and Isaac Robinson were early postmasters in a building adjacent to this one on the corner of Prospect Avenue and Hill Street. Clyde Teasdale and Bob McCauley served during the early 1900s. Mail from Benton arrived early in the morning. Residents in Shullsburg could receive letters mailed the same day. The last mail went out from New Diggings when Catherine Stephens was the postmistress. (Courtesy William and Priscilla Edge.)

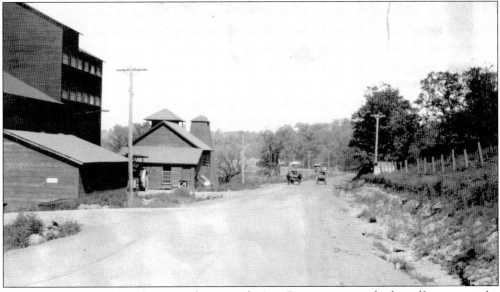

The road between the Champion home and New Diggings was a high-traffic area at the beginning of the 20th century. Their home was the scene of many parties. Behind their home was a complex of housing for miners. At the north side of the road, a spring bubbled cool water for a thirsty traveler, whether by horseback, buggy, ore wagon, or on foot. (Courtesy Harold and Geneva Beals.)

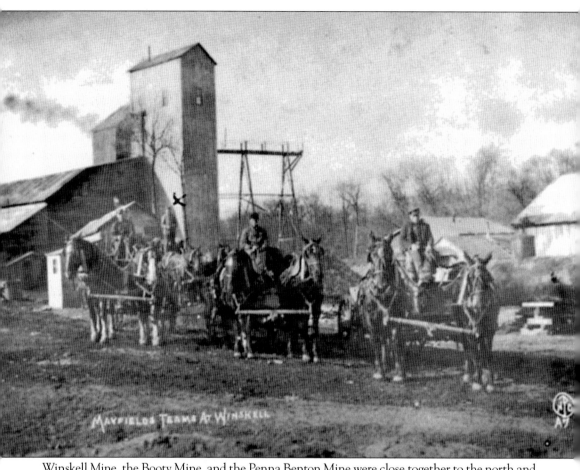

Winskell Mine, the Booty Mine, and the Penna Benton Mine were close together to the north and east of New Diggings. Mayfield horses were used to haul ore from the Winskell Mine. Dump bottom wagons were used to avoid excessive lifting and shoveling. (Courtesy Badger Mine Museum.)

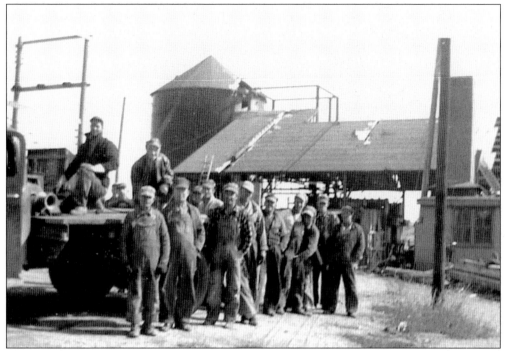

Mines in the New Diggings area before 1900 included the Jug Handle, Empress, Blende Ida Blende, Ollie Belle, Rooney, and Swift and Haskings. They were heavy producers. The Lucky 12, which was discovered by a man whose last name was Lucky, opened in 1908. This picture, taken in the late 1930s, shows the need for men with carpentry skills.

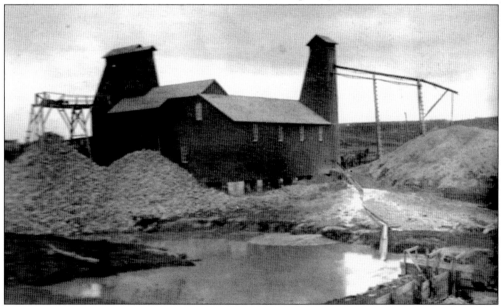

During World War I, the large producers were Champion, Penna Benton, Meloy, Haskins, Jack of Diamonds, Longhorn, CAT (Charles A. Thompson), and Booty Mines. Sometimes there was additional recovery from tailings. This work was done by the Chestnut Hill Zinc Company. When government subsidies were removed in 1947, many mines were forced to close.

News spread around that the photographer would be in New Diggings. It was a busy day for people like Florence and Henry Edge who drove all the way from their farm near Scales Mound to pose. While their carriage was similar to the Mullen rig, the tongue and yoke allowed for two horses to pull their fashionable rig. The horses may have been distracted by other horses. (Courtesy Norene Thompson Pfeil.)

Three
COTTONWOOD

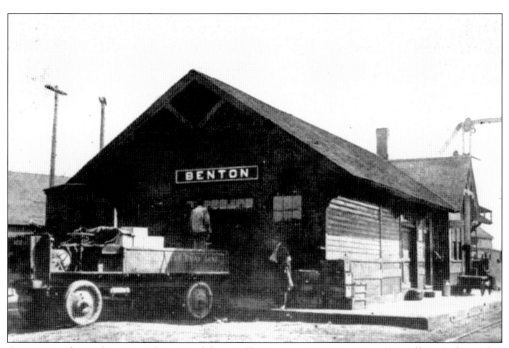

Cottonwood was the original name of the small mining community near Swindlers' Ridge, a few miles north and east of the new digs. The village of Benton was settled around the Frontier Mine in 1844 and became incorporated in 1892. Later the Chicago and Northwestern Railroad came through on its way from Galena to Elmo. (Courtesy Lafayette County Historical Society.)

Raisbeck Horsley, who was born in Laxey, Isle of Man, worked at the Benton Depot in the early 1900s. He suffered a serious foot injury while working. Like other men from the British Isles, he came to this country looking for a better life. He and his countrymen, like the Cornishmen, John Abraham and Francis Clyman of Gratiot's Grove and Joe Kitto of New Digs, were in the minority in this area.

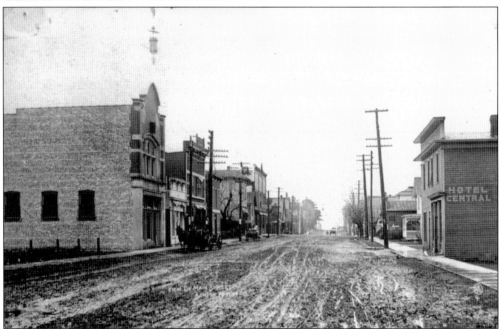

Belle Quilan was the first mayor of Benton. She was also a lawyer and notary public. In 1845, the town was officially named for Thomas Hart Benton, a man who promoted the lead-mining industry while he served in the U.S. Congress (1821–1851). A well was dug and the stone tower was built beside the power plant. Seen here is the muddy Main Street of 19th century Benton.

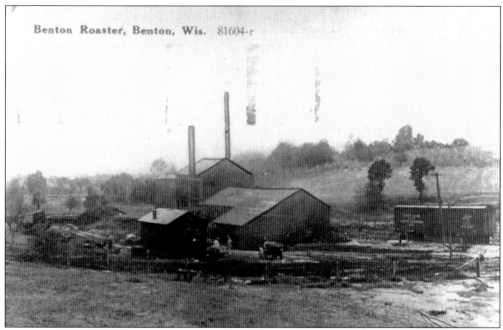

There were so many mines in the area, their drifts often led into each other. The Calvert Block House Mine was located north of the town. The National or Benton Roaster, shown here, and the Kennedy Mine were located south of town. The Martin Mine was on the Ollie Belle Road between New Diggings and Benton. (Courtesy Badger Mine Museum.)

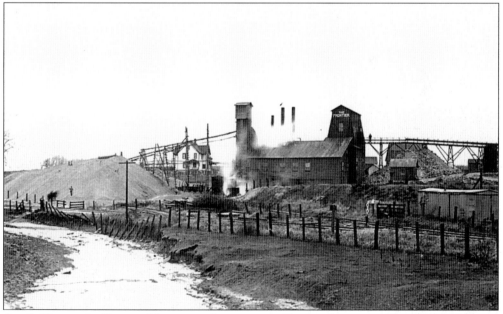

A rail siding at the Frontier Mine carried concentrated lead and zinc ores. The tramway hovered over the boulder pile. The shorter building in the center was the mill where ore was separated from the rock. The tall structure to the left shows the elevator containing a moving belt with buckets, which carried tailings to the sluice which led to the tailing pile. Workers could stay at the boardinghouse, seen in the background. (Courtesy Badger Mine Museum.)

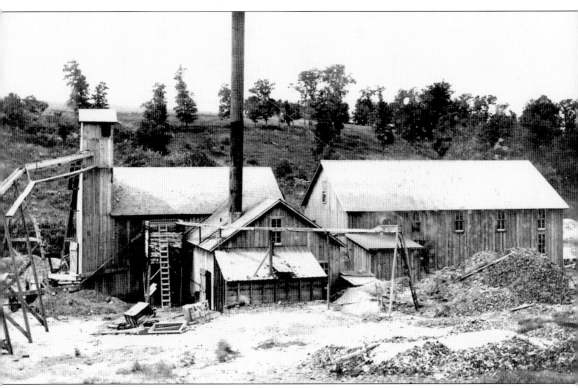

The spidery supports on the tramway make this mine unique. The grizzly, the slanted part of a mine where the rocks were separated according to size, was about halfway up in the tower. Two men were assigned to work there, one on either side of a grate which allowed smaller pieces to fall through.

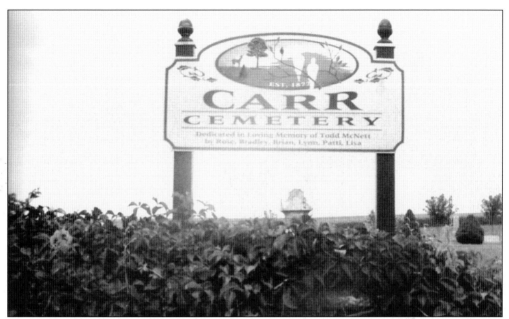

Covered with vines, the old rock wall around the Carr Cemetery reminds visitors of Britain. Benjamin and Peter Carr moved from New Diggings and settled between Lead Ville and Buzzard's Roost to farm. They did some prospecting also. The Carr Cheese Factory remained as a family business for about a century. Timothy Giles took over the operation but kept the name of Carr Cheese Factory.

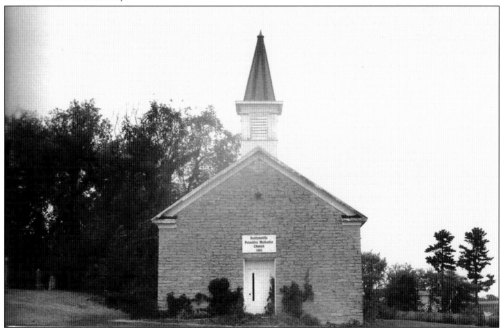

According to old records, Buzzard's Roost became known as Jenkynsville. When it obtained a post office, Moses Meeker became the first postmaster and the official name of the town became Meeker's Grove. The Jenkynsville Primitive Methodist Church and Cemetery (seen here), a store, and a stone house are all that remain.

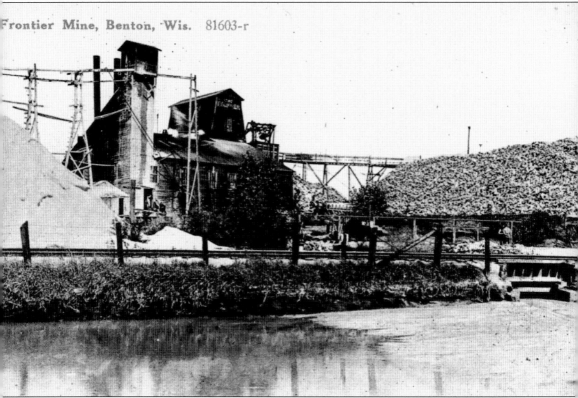

The village of Benton was built around the mine which became known as the Frontier Mine. A railroad spur line served it. Note the two piles of waste, one of rocks and the other that has been processed into tailings. The drifts of three mines eventually became connected. (Courtesy Badger Mine Museum.)

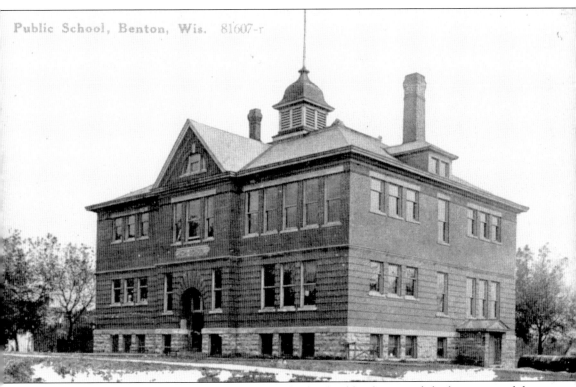

Benton School, with attached gymnasium, was built of red bricks around the beginning of the 20th century. It remained until the late 1900s, when it became necessary to build a new school. The property has been used as a playground. (Courtesy Rena Mullen Amacher.)

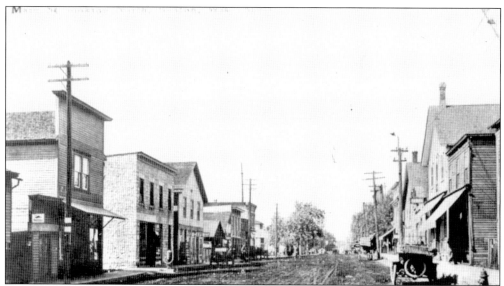

After Oscar Horsley returned from World War I, he opened Tut's Store on the north side of Main Street. The popcorn popper with a mechanical toy on top served as a fascination for kids. Sophie Kittoe worked for him. Carrie McLaughlin had a dry goods store next door and lived across the street. Hers was the first business to acquire a telephone. After the Blende Theater closed, it was used as a roller rink. (Courtesy Rena Mullen Amacher.)

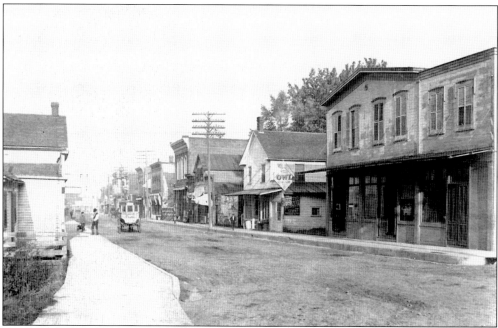

Improvements in Main Street at the beginning of the 20th century included telephone poles. The Methodist church and cemetery are on the main street. Everyone called the editor of the *Benton Advocate* "Pop" Vale. The paper was published weekly, for many years. (Courtesy Rena Mullen Amacher.)

Four

SHULLSBURG

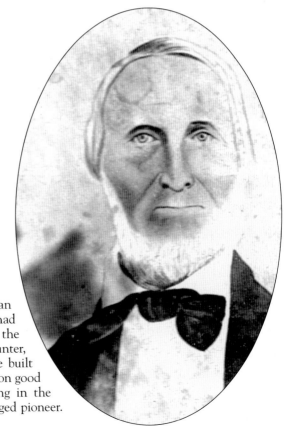

Trained as a hatter, Jesse Shull was an agent for John Jacob Astor in 1818. He had already traveled extensively between the Midwest and Pennsylvania. He was a hunter, prospector, trader, and businessman. He built his first log cabin home in 1823. He was on good terms with the Native Americans living in the area. Shullsburg was named for this rugged pioneer. (Courtesy Badger Mine Museum.)

The Shullsburg Branch began as a trickle not far from Irish Digs in peaceful farmland. It wound south and westward around Leadmine where it made a complete horseshoe around the Coltman Mine and eventually emptied into the Fever River. Murphy's Mill made use of a dam near Horseshoe Bend.

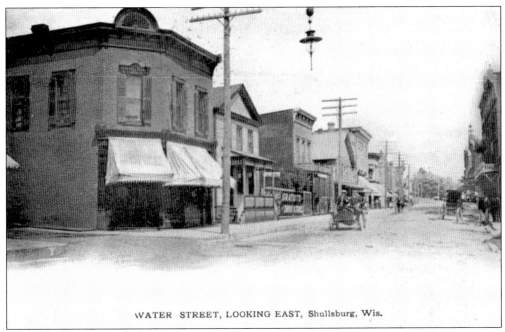

WATER STREET, LOOKING EAST, Shullsburg, Wis.

The first store in this block of West Water Street was John Hebenstreit's corner store. The original frame building burned in the late 1800s. The opposite corner store was occupied by the butcher shop of Dutch Bergener in the early days. His son, Fred, learned the business and reportedly sold sirloin steaks cut right behind the horns at 15¢ a pound.

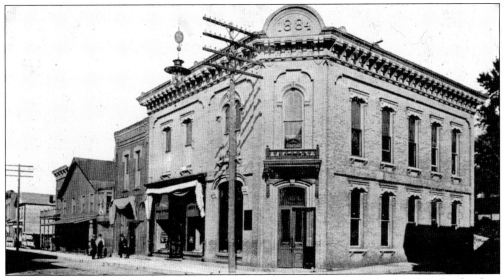

The First National Bank was built on the corner of Iowa Street in 1884 from Milwaukee brick in the Italianate style. It was designed by C. C. Gratiot using funds from the J. K. Williams estate. Dr. Blackstone's office was on the second floor in the early days. It is shown with the hanging light of the early 1900s. Later, Dr. J. C. Hanifer had his dentistry office on the second floor. (Courtesy Rena Mullen Amacher.)

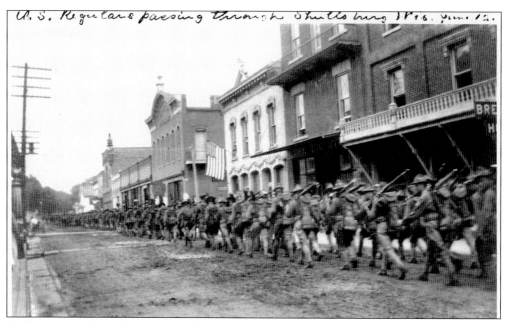

Looking east as the military passed through Shullsburg, one would have seen the First National Bank looming at the corner of the 200 block. Spirits were high as the soldiers laughed and threw souvenirs in the form of ammunition into the crowd.

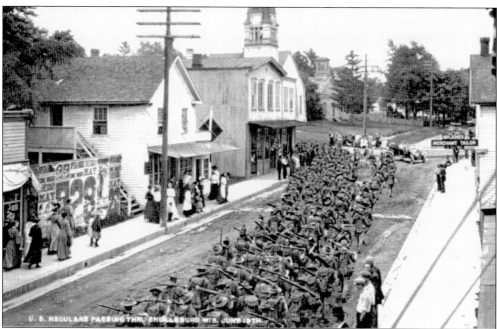

Looking east on Water Street in 1912, the U.S. regulars marched past the Merchant Tailor's shop where the Burns family lived for many years. The Congregational church was on the northeast corner of Judgment and Water Streets. Honeycomb's business was on the corner of the block. Note the vintage car in the intersection.

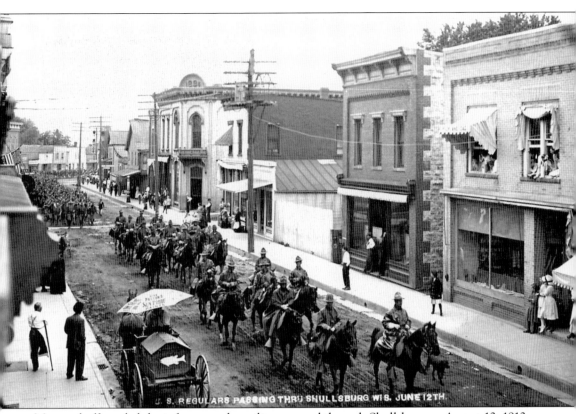

Mounted officers led the infantry as the military passed through Shullsburg on August 12, 1912, on their route between Dubuque, Iowa, and Sparta, Wisconsin, later more popularly known as Fort McCoy. People reportedly came from miles around to see the parade through town. Note a man on the south side of the street, apparently missing a leg. Notice the horse and wagon with an umbrella in the foreground. Young women watched from the doorway of the store which was later owned by Irvin and Inez Jan. Men looked out form the front of the tavern that Herbert Ryan operated in the 1950s. (Courtesy Rena Muller Amacher.)

The first lamps were on posts similar to those in Britain. In 1903, the city marshall filled the lamps, cleaned them, and lit them every night. He extinguished them in the morning. He also repaired the streets and wooden sidewalks where needed. Known as "Tug" Henry, he was a necessary part of life in the 1800s. Known as Honeycomb Corner, the property on the northeast corner was owned by John Honeycomb as early as the 1860s. (Courtesy Rena Mullen Amacher.)

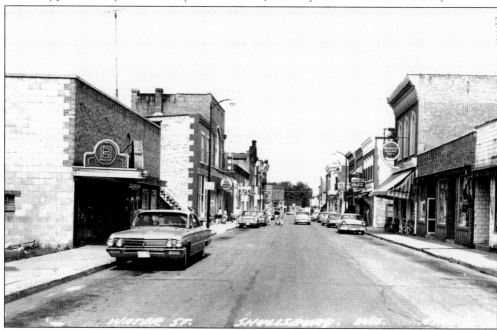

The Burg Theater was built in 1949 and managed by Wally Nordquist, Bill Lind, F. J. Leahy, and Ron Foley until it was destroyed by fire in 1996. For many years, Will Jones had a tailor shop in one of Shullsburg's original buildings, the James Hatch Building. There were two grocery stores in this block in the mid-1900s, Leahy's Red Bell and Tregloan's Royal Blue Store.

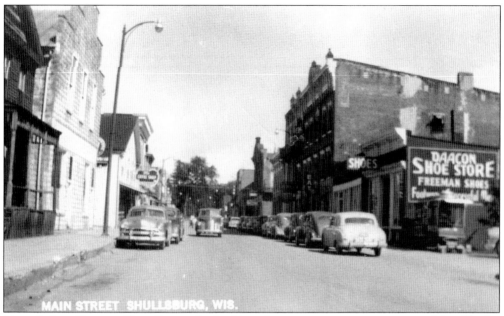

Identified as Daacon Shoe Store, the building began as a restaurant operated by Charles Alexander. Other proprietors of this corner store have included Stacia Doyle and Ben Lyne. George Daacon sold shoes here for a number of years in the 1940s, and later it was operated by John Engels. The Knights of Columbus met there as well. Across the street was the locker operated by the Gile family. (Courtesy Rena Muller Amacher.)

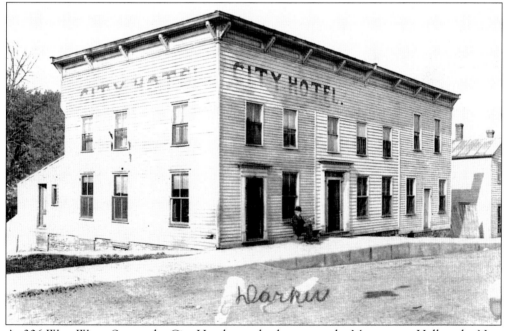

At 306 West Water Street, the City Hotel was also known as the Monetzuma Hall or the New York House. It was built in 1847 and purchased by the Egan family in 1891. In the 1960s and 1970s, it was used as a pizza place. Charles Berryman restored it in 1974. Virgil Ryan and his wife lived there.

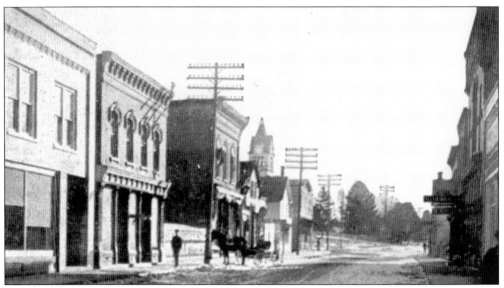

Gerlach's saloon was destroyed by a fire on Christmas Eve 1902. The school's band instruments were stored there. The building was rebuilt and reopened by the Law family. The new structure was made of rock and brick to prevent future catastrophes. The *Pick and Gad* was published on the second floor for many years. Other persons who had businesses since then have been Harold Morrissey, Leone Edwards, and Irvin and Inez Jan.

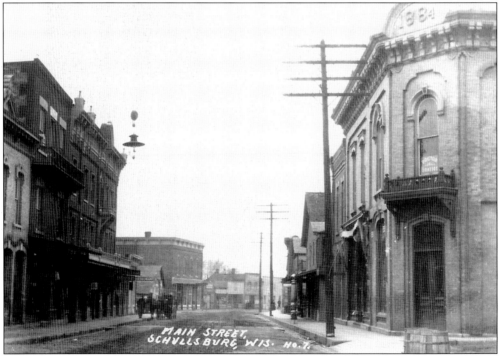

Samuel Brewster built a three-story brick hotel on the south side of Water Street in 1886. Overnight visitors came from the train station on Jim Hurley's horse-drawn bus and ate in the elegant dining room. In recent years, diners have enjoyed the unique interior and homestyle cooking. (Courtesy Rena Muller Amacher.)

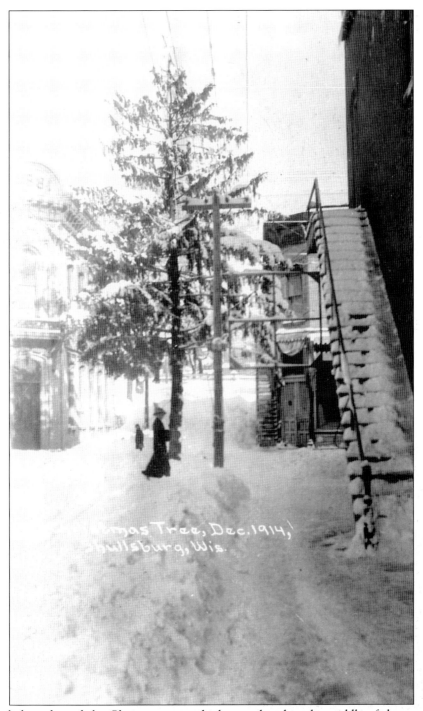

Electric lights adorned the Christmas tree which was placed in the middle of the street near the Copeland Opera House on Water Street the week before Christmas. Record-setting subzero temperatures discouraged shoppers from lingering to observe the rare and beautiful event. Built by Joseph Copeland in 1882 using locally made Townsend bricks, the opera house seated 600 people and was used as a movie theater in the 1940s. (Courtesy Rena Mullen Amacher.)

Roy and Myrtle O'Neill lived in a two-story house on North Judgment Street. The house, with a unique rounded roof on part of the porch, was across the street from the school. He worked as a shoe salesman and a carpenter for many years before he was elected to serve as register of deeds for Lafayette County. She taught at New Diggings.

Herbert Ryan Sr. had a love of farming. He ran the tavern on the north side of Water Street for many years and kept a few small animals on a lot just west of town. His son, Virgil, served in the U.S. Navy and later operated a pizza parlor. (Courtesy Maxine Ryan Hess.)

The south part of town was a wasteland of rocks until the 1930s when Dr. J. C. Hanifan and Dr. Henry Hoesley spearheaded an effort to make it into a park. Government funds and local manpower were used to create a natural seating area and the swimming pool. Pictured here, from left to right, are Gary Redfearn, Norene Thompson, and March children Richard, Carol, Donna, Harold, Connie, and Eleanor.

St. Matthews students in this 1947 picture include Margory Wolfram, Marjie Trebian, Marie Aurit, Glen Mulcahy, Odella Cherrey, James Chaffee, Loretta Davis, Mary Gehrt, Ronald Fox, Joan Hoppenjan, Joan O'Brien, Patrick Kennedy, Ted burns, Robert Logan, Betty Jane Blaine, Betty Logan, Anna Jane Keyes, Bridgett Cavanaugh, Larry O'Brien, Wayne Gerht, Charles Gile, Joseph Gleason, and Tom Whalen. Those standing in the back from left to right are George Burns, Donald Hoppenjan, Sr. Mary Beatrice, James Fisher, Elaine Schaffner, and Mary Kennedy.

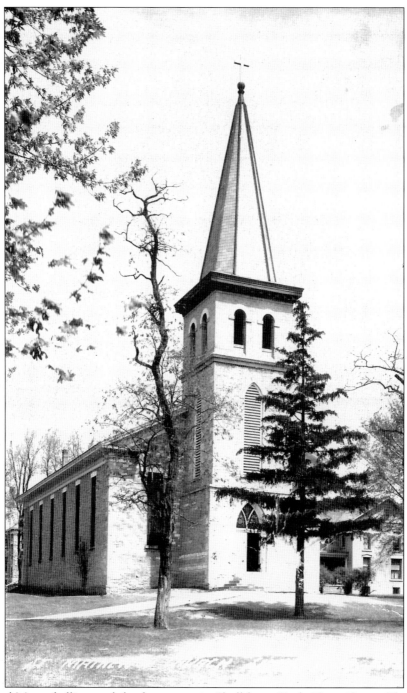

Fr. Samuel Mazzuchelli named the first streets in Shullsbsurg Faith, Hope, Peace, Charity, and Judgment. In 1841, St. Matthews, a small frame church with a domed steeple, was constructed. The timbers were cut in Galena and hauled to the site where they were assembled. Catholic Church Square included a park and cemetery. The bishop of Dubuque visited when the church was dedicated. It is said that the priest was able to quiet fights at the local saloons. (Courtesy Rena Mullen Amacher.)

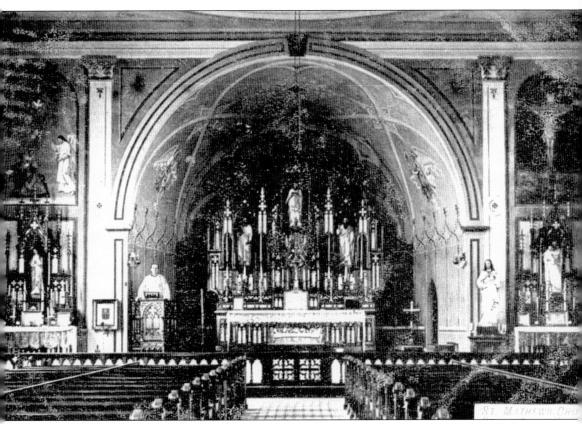

Due to limited funds, the interior of St. Matthews was not completed until 1883. Like Father Kelly's other churches, it was beautiful and awe-inspiring. The most impressive feature of this interior was the set of 14 life-size paintings depicting steps Christ took on his way to the crucifixion, called the *Stations of the Cross*. (Courtesy Rena Mullen Amacher.)

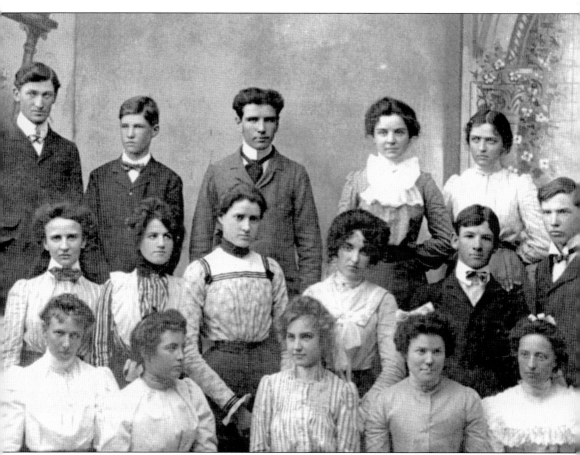

Classes began in the new building in December 1900, and this class graduated the following June. Pictured from left to right are (first row) Fay Hancock Spencer, Eulalia Oates, Alice Thompson Anderson, Maude Glendenning, and May Wurm; (second row) Leora Leahy O'Neill, Mabel Bergner, Lula March, Leona McNaughton Richardson, Charley Bergner, and Charles Gratiot; (third row) Ralph Pedelty, Charley Meloy, Will Metcalf, Jennie Cavanaugh Golf, and Bessie Bushby Gratiot.

Forward-thinking members of the school boards have wisely preserved this building. The pillars with arched doorways, the windows, and the bell tower have been a source of community pride for over 100 years. In 1942, architects, planning for the use of native limestone on the new gymnasium, created a fine addition that blended well with the existing structure. (Courtesy Rena Mullen Amacher.)

Shullsburg School, which replaced the one destroyed by fire in 1889, was constructed of limestone from the Rennick Quarry south of town. The arches over the front doors made this building unique. Classes were held for children in grades 1 through 12. This picture shows some younger children playing in the snow while a teacher supervises. (Courtesy Rena Mullen Amacher.)

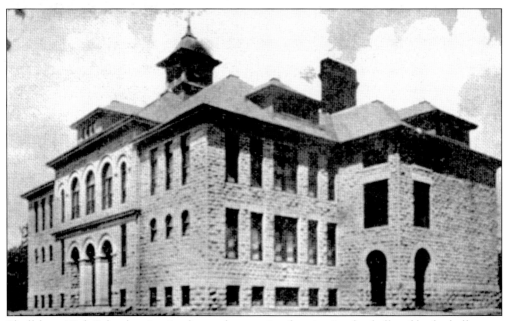

Shullsburg High School maintained a good reputation for winning football and basketball teams as well as band and chorus groups. Many valuable programs have been added over the years. A large percent of the graduates continue their studies at universities and technical schools. This is a tribute to highly qualified teachers and dedicated board members. (Courtesy Rena Mullen Amacher.)

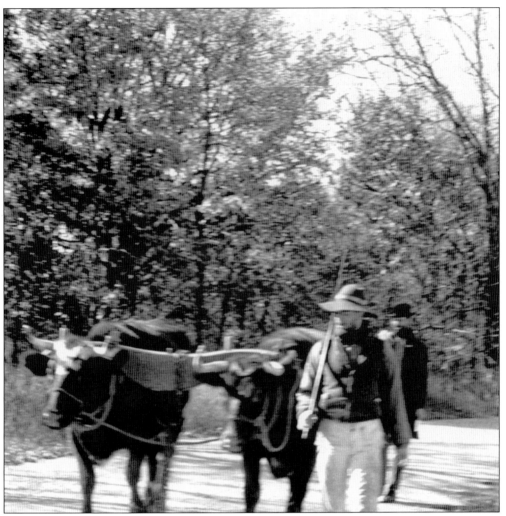

People living on East Water Street before 1881 reported seeing heavy wagons pulled by multiple teams of horses or oxen. They passed the big cottonwood in Miss Hoskns's pasture quietly carrying ore from the smelters to the Illinois Central Depot in Scales Mound. The two smelters belonged to Alfred Quinch and Joseph Hutchinson. When the railroad went through it was easier but noisier getting ore to market.

Margaret (left) and Sarah Metcalf grew up in a house on East Water Street and trained as teachers. Margaret became a supervisor and Sarah taught in Lake Geneva, later becoming a principal. She returned home to care for her invalid mother. She operated a millinery store and later joined her brother, Sam, in managing a department store in the Copeland building. (Courtesy Angie Dickinson Schmidt.)

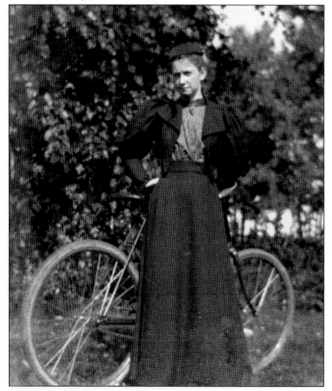

Around the dawn of the 20th century, bicycles were a popular mode of transportation. The young women in Shullsburg formed a bicycle club so they could ride together in safety. Roads were becoming more navigable, even if only in good weather. Long skirts, however, which were the fashion, must have been cumbersome.

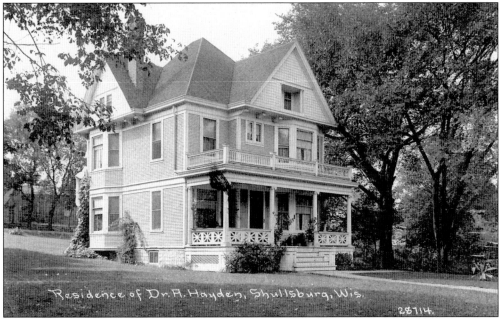

Dr. A. Hayden's residence was set back from the road leading to Gratiot's Grove. He practiced medicine here in the late 1800s. Before him, Dr. Tyrell and Dr. A. P. Ladd provided care for residents. Squire James lived in a log house and was often visited by P. B. Simpson, J. K. Williams, Marvin Hollister, and other prominent figures of the time.

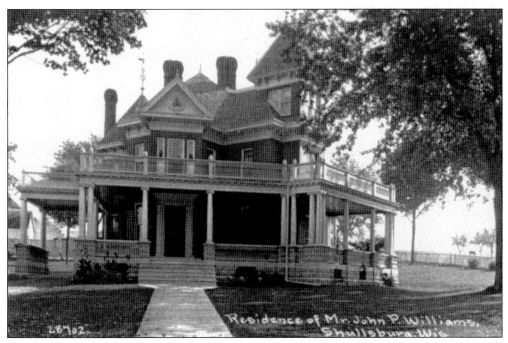

Another impressive home on South Judgment belonged to John Williams and had been designed by C. C. Gratiot. Next door, Samuel Rickert had built a home in 1852 to replace the log cabin near the spot where he struck it rich.

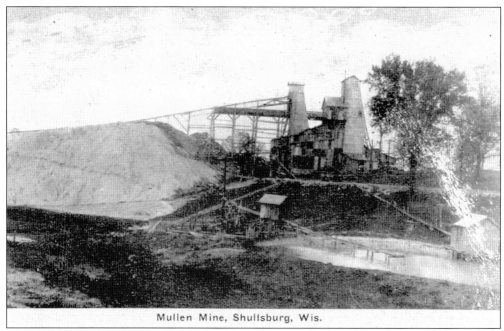

Mullen Mine, Shullsburg, Wis.

The Old Mullen Mine, discovered in 1921, was part of the James-Doyle-Harty chain, which included three miles of drifts. In 1968, an incline appropriately named the Bear Hole was introduced at the James Mine.

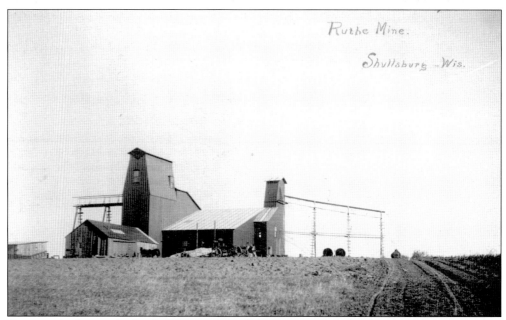

Deep ruts leading to the Ruthe Mine were made by heavy ore wagons during early times. Milled lead was hauled into town on horse-drawn wagons. Some men kept several teams of draft horses to work for the mines. The teamster of the day rolled the wagon onto the scale to be weighed before the ore was loaded into freight cars. The teamster had to unload the ore from the wagon with a shovel. (Courtesy George Burns.)

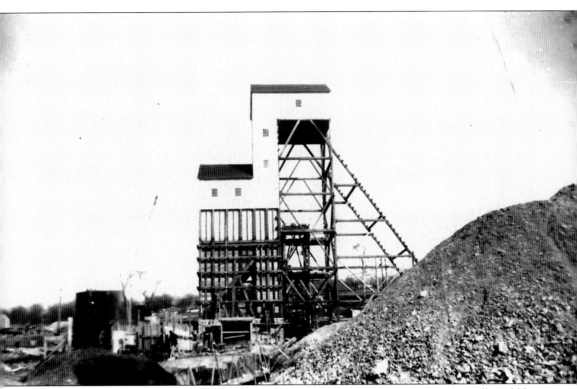

When the Calumet and Hecla Mine began operation, it was some time before the mill could be built. Other parts of the operation were in full swing so a large pile of rocks accumulated. Later the mill pulverized the ore and separated the lead, zinc, and unusable rock. The separated ore would then be ready for the flotation process.

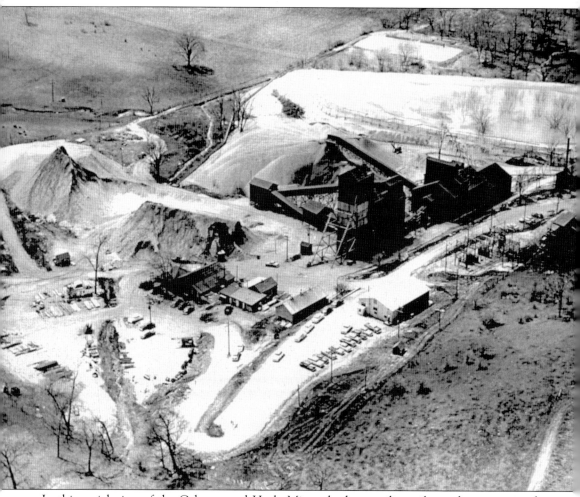

In this aerial view of the Calumet and Hecla Mine, the huge tailing piles and a reservoir of water are visible. Taken about 1950, the picture shows that the mine had been in operation for a long time. It was purchased by the Eagle Picher Company for $4.5 million. It was furnished with modern equipment. (Courtesy Badger Mine Museum.)

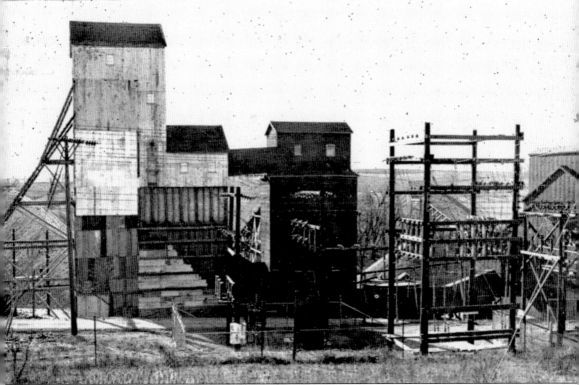

The Calumet and Hecla Consolidated Copper Company owned the biggest mine in the Shullsburg area. The company brought in the latest equipment, which had been in use in copper mines of Michigan. The rich area was discovered in 1947. Drifts went northward about a mile under the ground and reached the Kittoe Mine. Drifts to the south reached the Gensler deposits. (Courtesy Badger Mine Museum.)

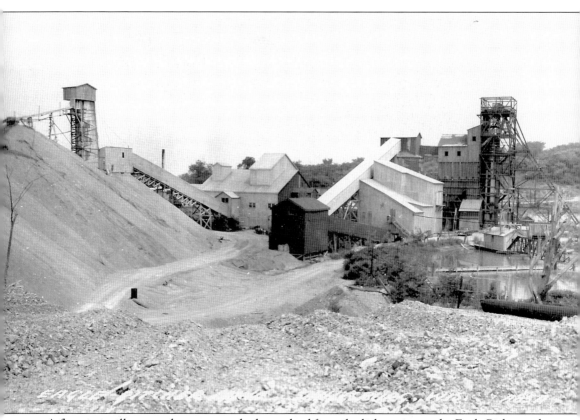

A flotation mill was used to separate the heavy lead from the lighter zinc at the Eagle Picher and other mines. It was more advanced than the older jigging process but required a great deal of water, as evidenced on the right-hand side of the picture. (Courtesy Badger Mine Museum.)

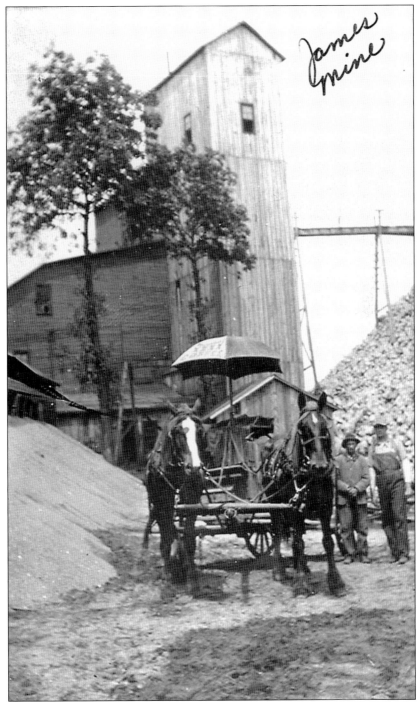

Horses were used to pull the wagons loaded with ore. Men had to load and unload the wagons with shovels. When machines came into use, work for men and horses became much lighter. At the James Mine, horses took ore to the depot in Shullsburg to be weighed and sent on the train to markets. This mine was in operation from 1925 to 1936, and then reopened during World War II. (Courtesy Badger Mine Museum.)

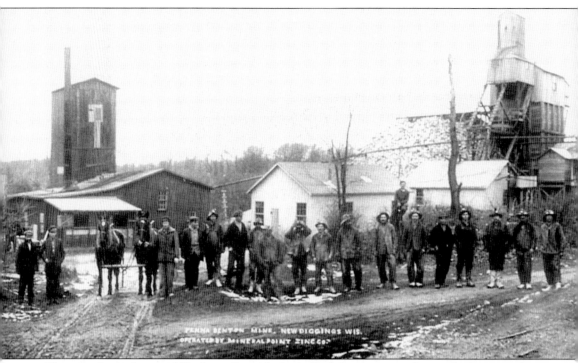

The mixed population of Yankees, Cornish, Irish, Yorkshire men, and more Irish was said to have gotten along well together. An old-timer related that they would fight and drink, shake hands, and fight again. Eventually they brought their families and their traditions to the "Land of Gray Gold." Irish had their soda bread and leprechauns while the Cornish ate pasties and laughed about tommy knockers. (Courtesy Rena Mullen Amacher.)

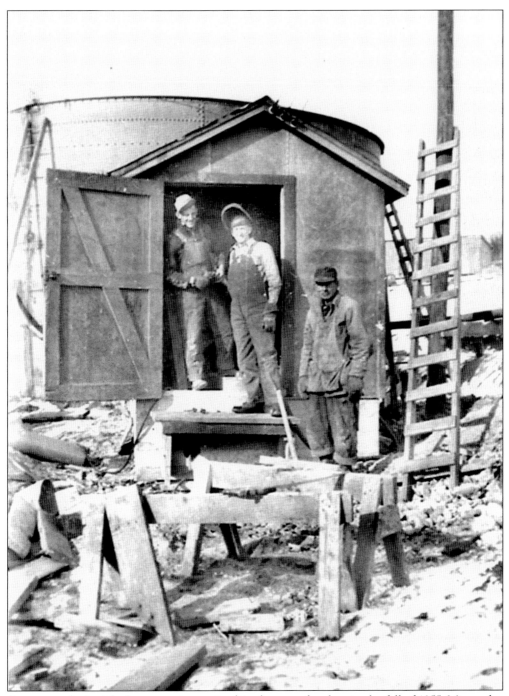

An escape shaft with three men is seen in this photograph taken in the fall of 1955. Mines also had "doghouses" where men could hang their clothes. They kept the fire going in the stove. Many times it was necessary to change their clothes before going home because it was extremely wet underground. (Courtesy Badger Mine Museum.)

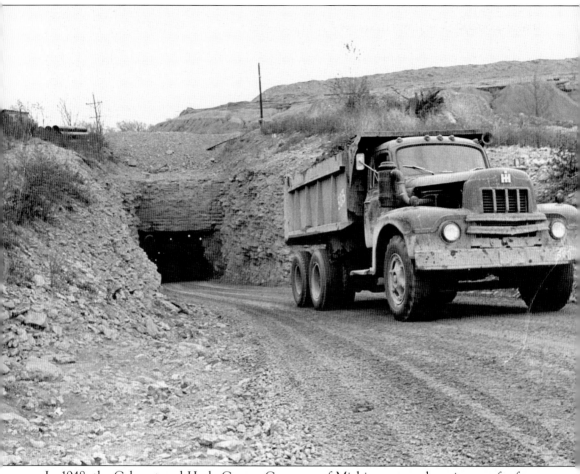

In 1948, the Calumet and Hecla Copper Company of Michigan opened a mine not far from Gratiot's original digs. It was sold to Eagle-Pitcher in 1954. It was the first in the area to use large underground excavation equipment. Sometimes a truck would be taken apart and reassembled at the underground worksite.

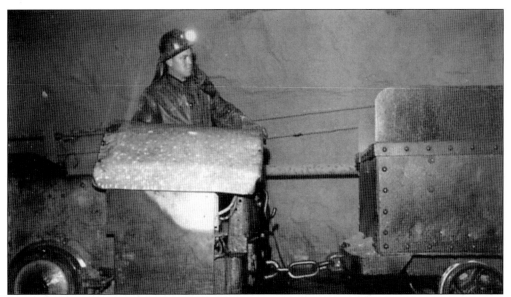

Underground rail cars made mining much easier. Mules were retired along with the muleskinners who handled them. By the 1950s, shovelers had been replaced by air-operated scoops. In earlier days, ore was hoisted to the surface in large buckets or cans. Men who did this, called hoistermen, were assisted by "hookers," whose job was to connect a chain to the ring on the bottom of the bucket so it could be emptied at the grizzly. (Courtesy Badger Mine Museum.)

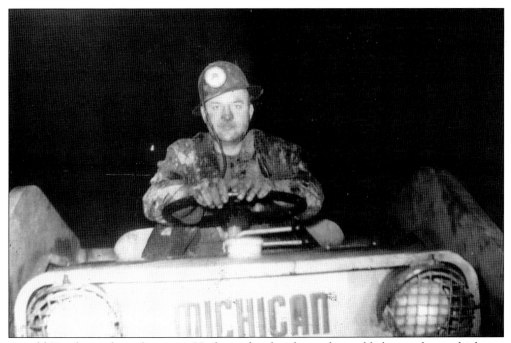

Arnold Fox drives through a mine. His hat is fitted with a rechargeable battery lamp which was far better than the carbide lamps and tallow lamps, which replaced candles. (Courtesy Badger Mine Museum.)

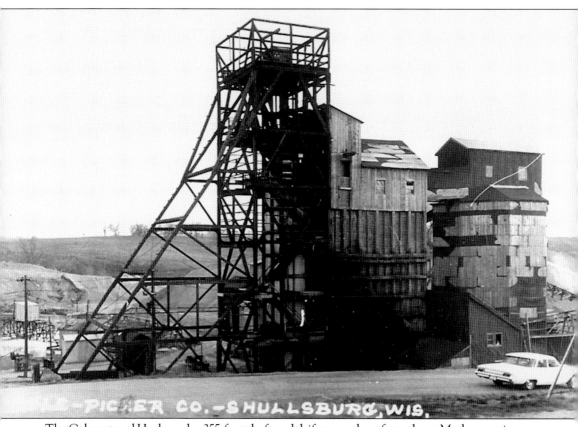

The Calumet and Hecla sank a 355-foot shaft and drifts spread out from there. Modern equipment like hoisted caged skips were used. A 1,200-ton flotation mill was installed. The mine closed in 1979 after operating for 30 years and producing over 7,000 tons of ore. (Courtesy Badger Mine Museum.)

Five

FARMS AND SMALL TOWNS

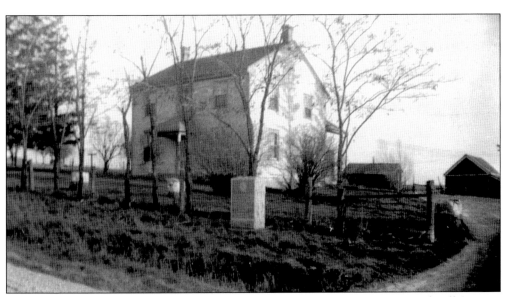

The stagecoach road, which ran past Berry's Tavern, Gratiot's Grove, and Signal Hill Station, was no more than tracks through the wilderness, muddy ruts in wet weather, and clouds of dust when it was dry. At one time, John Howe drove a four-horse hitch on the stagecoach. Berry's Tavern offered the crudest of accommodations, but it was a welcome resting place for weary travelers.

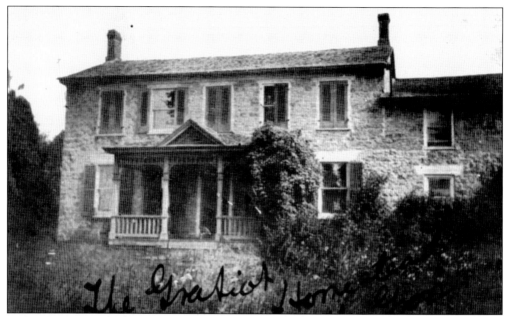

Col. Henry Gratiot bought the first survey after the Point of Beginning was established. He and his brother Beon brought their wives and children, then hired a teacher creating the first public school in Wisconsin Territory. Beaulah Lamb taught classes in a log store until Black Hawk threatened to attack. The women and children went to Fort Hamilton and Galena where they were safe.

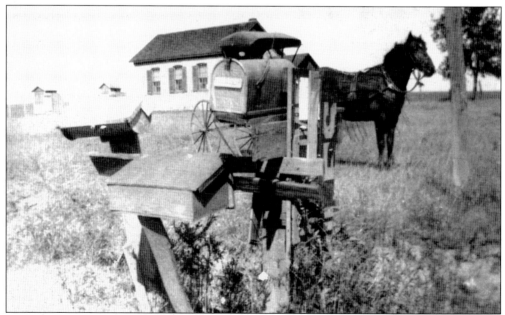

Later, one-room schools appeared along the dirt roads all around the state. There were 120 in Lafayette County in 1875. White Thorne School, built of native limestone about 1850, was on an intersection between Gratiot's Grove and Berry's Tavern. The dirt of this road was one of the first to be covered with mine tailings, which were readily available from the Calumet and Hecla Mine.

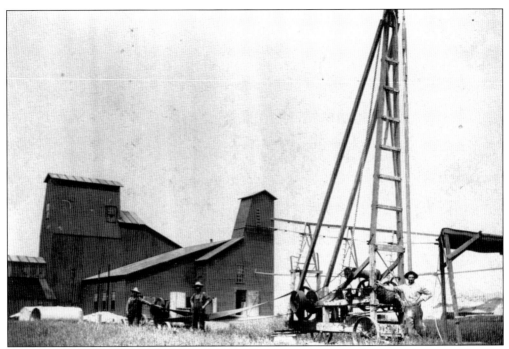

A mine could pump 1,000 pounds of water per minute, lowering the groundwater table. The company drilled to learn of the direction it should go with its next drifts. Using drills like this, the company drilled wells for farmers and in the process, searched for more ore deposits. One summer in the 1940s, the company also drilled a new well at White Thorne School. (Courtesy Badger Mine Museum.)

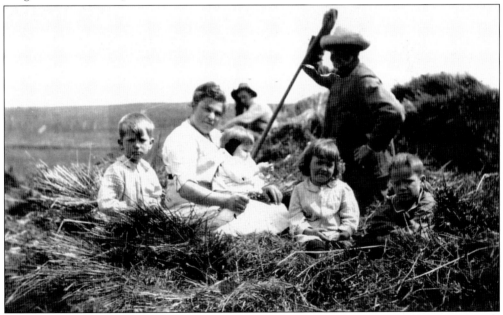

Edward Ocean White took over the family farm at Signal Hill in the late 1800s. His wife, Emma, and children are shown sitting on a pile of hay. The children attended White Thorne School. Cyril and Arch continued working on the farm until the mid-1900s. (Courtesy Nancy Custer.)

Lavery and Richards were the names of farm owners east of Shullsburg in the early days. To the south were Thomas McNulty, Thomas White, and two March brothers, John and Ned. When Thomas White came here from Yorkshire, England, he found Native American furnaces scattered through the timber on the hill which was later referred to as White's Hill. Adjacent to it was Gratiot's pasture, which was honeycombed with shafts and drifts. (Courtesy Nancy Custer.)

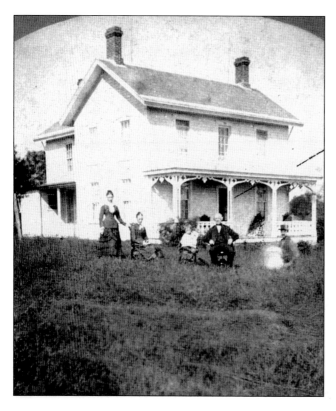

Thomas White bought 240 acres at $1.25 each. It was his intention to raise pigs, sheep, and crops near friends and relatives from Yorkshire. In addition to a fine two-story home, he built a sheep barn, a hay barn, and a concrete hog barn with grain storage above it. He also raised and raced horses. (Courtesy Nancy Custer.)

Upper grade students at one-room schools like the one pictured here were expected to do daily chores. They pumped water from the well and filled the porcelain water bubbler. When children sipped from the bubbler, excess water ran into the bucket below to be used for hand-washing. (Courtesy Norene Thompson Pfeil.)

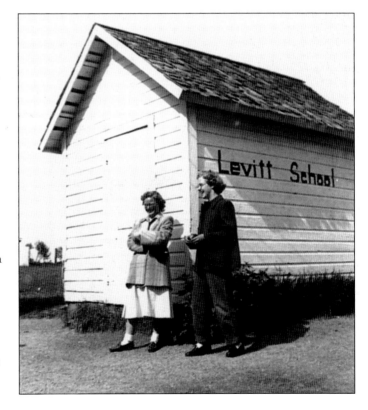

At Levitt School responsible students like Eleanor and Carol Glick carried wood from this unattached woodshed and stacked it near the wood-burning stove. When the school converted to a coal burner, the kids brought in the coal. Sometimes children would set their metal soup containers on the stove so the food would be warm in time for lunch. (Courtesy Norene Thompson Pfeil.)

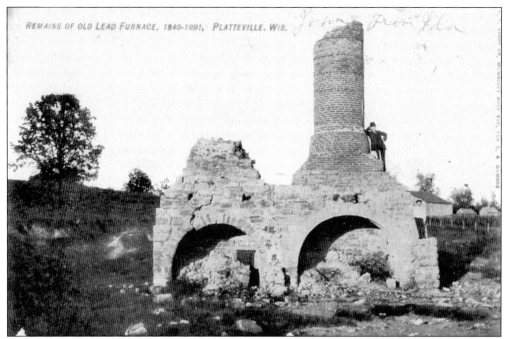

In the early days, Robert Drummond of White Oak Springs noticed log and ash furnaces were not very efficient. The furnace he invented allowed heat from the fire to pass over the top of the charge as well as underneath it. This blast-type furnace used a water wheel to drive the bellows and recovered much more lead from the ore. Pictured are the remains of a furnace at Platteville. (Courtesy Badger Mine Museum.)

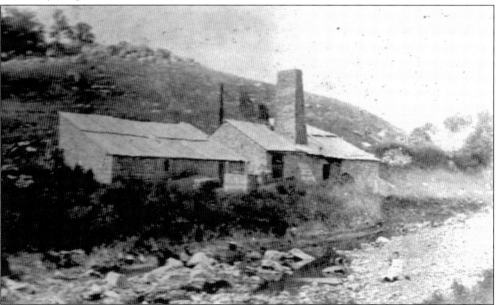

When zinc ore came from the ground, it contained large amounts of unneeded materials. It was heated or smelted to remove sulphur and other metallic impurities. Tons of ore needed to be processed at every mine, so in the early 1900s, mine owners wanted a furnace of their own. (Courtesy Badger Mine Museum.)

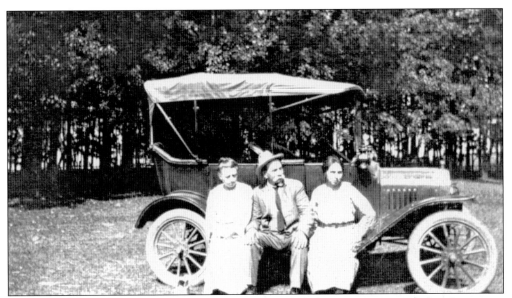

This was a memorable day in the lives of two White Oak Springs women, seen here sitting on the running board of William Hancock's car. Hancock had been voting for years. For his wife, Maude, and the neighbor woman, it was their first time. The back of the picture was dated September 7, 1920.

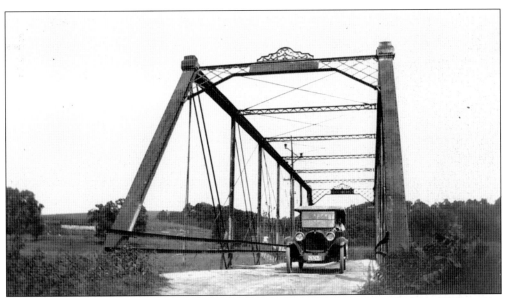

Henry Ford's Model T rolled off the assembly line in 1908, making cars affordable. Dodges like this one, owned by Henry Haser, and the Model A became popular for families in the 1930s. They could drive over bridges of steel construction along tailing-covered roads representative of the times in the mining area. Affordable cars brought farms and towns closer together in the early 1900s. (Courtesy Norene Thompson Pfeil.)

Walter Thompson's farm was in Monticello. He must have been a successful farmer in the early 1900s. Not only did he have a new suit of clothes but he also drove a shiny black car with a canvas top. Note the freestanding rock wall in the background. (Courtesy Norene Thompson Pfeil.)

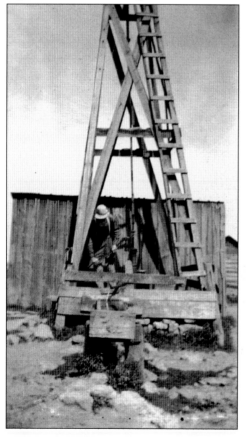

A fresh water supply was a precious commodity in the country as well as in towns. But unlike villagers, farmers were responsible for their own water supplies. John March, with help from his brother Ned and other neighbors, dug this well in the mid-1800s. The sturdy wooden structure over the well served the farm for many years, and the blades turned even into the next century.

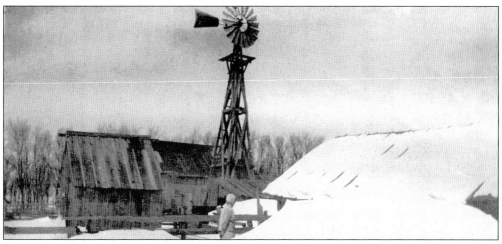

Severe Wisconsin weather caused many hardships for farmers. Paths had to be made through the snow so someone could get to the barn and feed the animals. Water troughs had to be cleared of ice so animals could drink from them. In order for the windmill to work, there had to be sufficient wind.

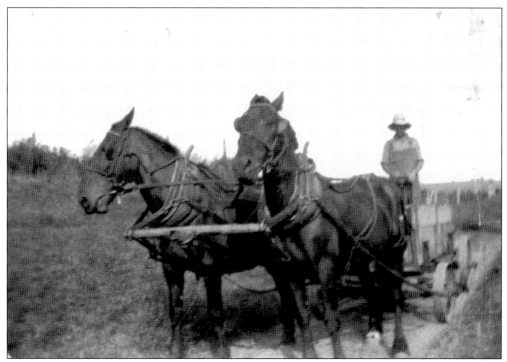

In the 1920s, farmers like Verdan Fawcett needed a dependable team of horses to plant, plow, and take crops to market. The metal wheels supported heavy loads on muddy or snow-covered roads. On Sunday the team was hitched to the buggy with thinner, lightweight wheels for the weekly trip to church.

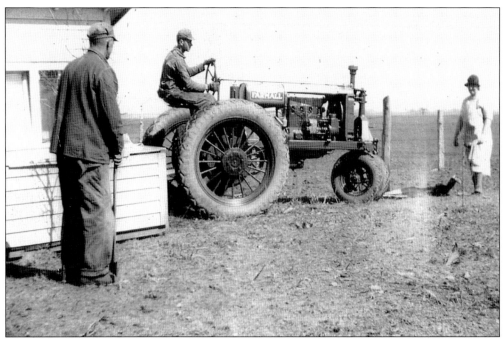

Young George Booth shows his parents, Pearl and Lester Booth, he could handle the Farmell. Heavy lifting was minimized with machines like this. George farmed for many years around Cuba City and worked for charitable organizations in his retirement.

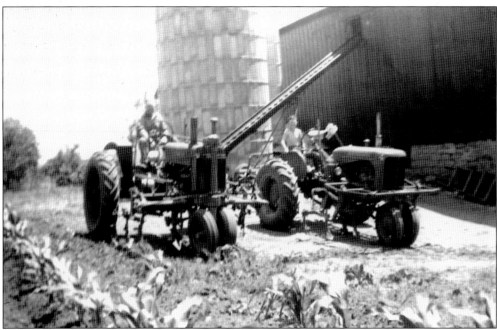

Cultivators, elevators, and silos made dramatic changes in agriculture during the 1940s and 1950s. Farmers were able to feed more cattle and till more acreage. Young men like Richard March were glad to take the wheel to cultivate, and his father, on the John Deere, was happy to have an extra farmhand.

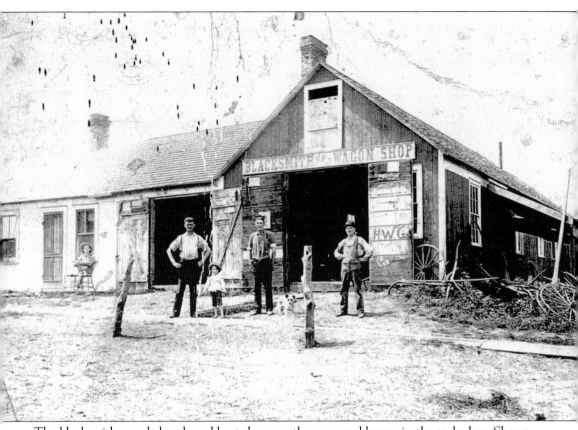

The blacksmith mended tools and kept shoes on the oxen and horses in the early days. Shown here is the Blacksmith and Wagon Shop in Cuba City. Henry Hillemeyer's forge was on the corner of Water and Mineral Streets in Shullsburg. Leo McKendry repaired farm machines during the mid-1900s in his shop also on Mineral Street. McKendry invented the Invalid-Aid Chair. (Courtesy City of Presidents.)

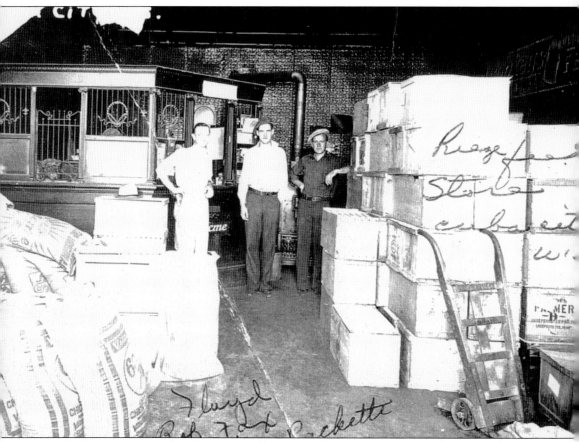

A feed store was a popular place in a small town too. Farmers in wagons, and later pickup trucks, pulled up in front to load up with feed that was not grown at home. In the 1920s, Joseph Harvey and Floyd Friege ran a store in Cuba City. They sold coal, feed, poultry, and flour. No doubt they traded for hides and eggs. (Courtesy City of Presidents.)

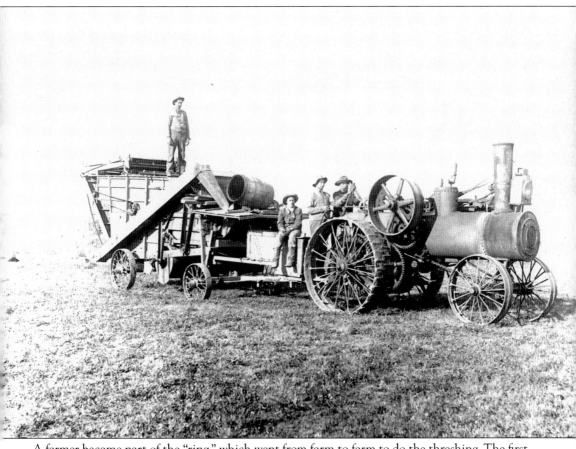

A farmer became part of the "ring," which went from farm to farm to do the threshing. The first threshing machine was a two-horse tread power. This one was owned by Noble and Dimmick. Another was owned by the Magee brothers. Due to the cost, dual ownership of this large piece of equipment was a necessity. (Courtesy Rena Mullen Amacher.)

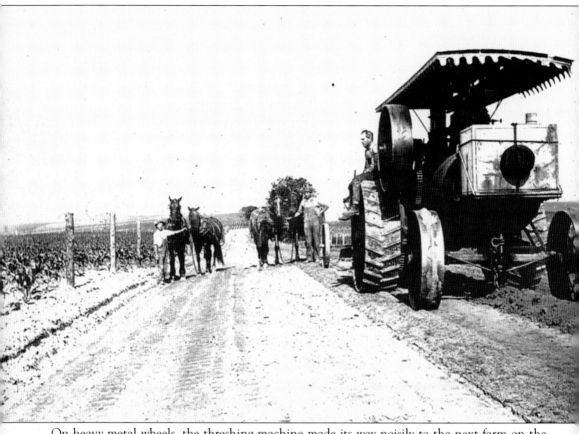

On heavy metal wheels, the threshing machine made its way noisily to the next farm on the threshing ring. Charles and Harry Magee owned the last steam-powered threshing machine in White Oak Springs.(Courtesy Rena Mullen Amacher.)

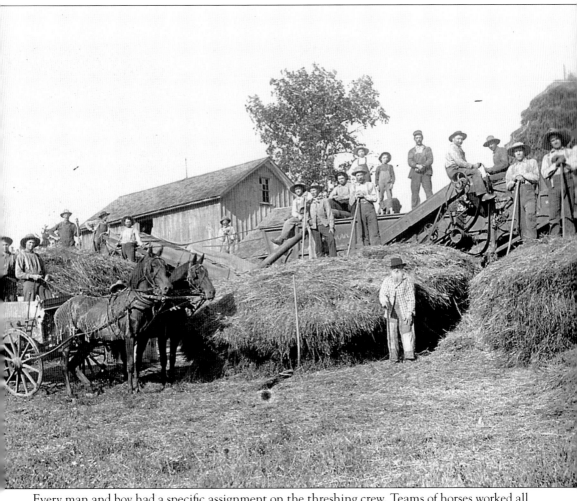

Every man and boy had a specific assignment on the threshing crew. Teams of horses worked all day to keep grain in the machine. In the morning, the chaff and straw began to flow from the thresher. It accumulated on the ground, and by afternoon, a huge pile of gold glistened in the sun. Nicholas Haser, in front, must have been the "boss" for this work day. (Courtesy Norene Thompson Pfeil.)

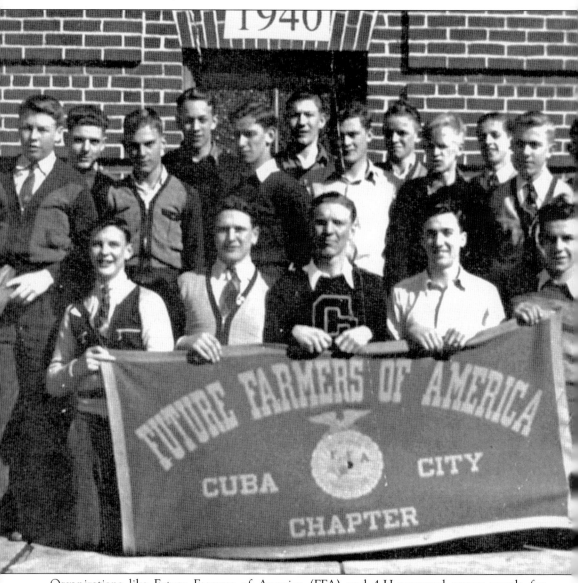

Organizations like Future Farmers of America (FFA) and 4-H prepared young people for farm-related jobs and careers. The FFA of Cuba City, a part of the high school agriculture program, was active before 1940. Even in the early 1900s, students were encouraged to attend the farmers' short course at the University of Wisconsin. (Courtesy City of Presidents.)

The Illinois Central Railroad went through Scales Mound before train service was available in Wisconsin, enabling mine owners to transport their ore to market. Known locally as the "Land of Corn," the whistle of the passenger train could be heard for miles around in the mid-1900s. Service continued for more than 100 years.

Homer and Alfred Thompson were willing workers growing up on the family farm near Council Hill. Blessed with a subtle sense of humor, Alfred often played tricks on his brother. Both men became prominent farmers. Homer and his wife moved to White Oak Springs and Alfred married a neighbor girl and farmed near Council Hill. (Courtesy Norene Thomspn Pfiel.)

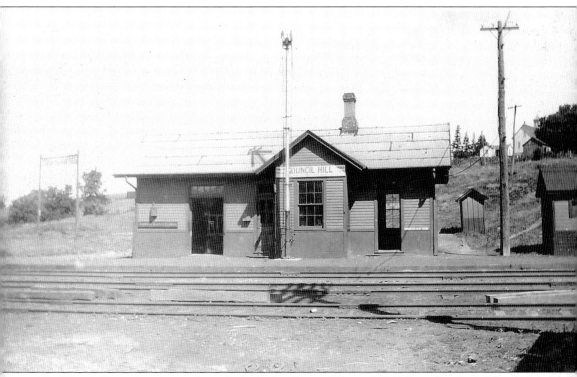

The Illinois Central train ran through the little village of Council Hill. Farm families of the area included Wills, Thompson, Lee, and Redfearn. The church, school, and 4-H became the centers of the social life in such rural communities. Most farmers and their wives eventually went to work in nearby towns. (Courtesy Norene Thompson Pfeil.)

This picture shows children and grown-ups alike dressed for a skit at the church picnic. Marion Redfearn once went as Little Red Riding Hood and her brother John Alden portrayed the wolf. Judging from the stove pipe hat and the American flag, one would assume this skit was more patriotic. (Courtesy Norene Thompson Pfeil.)

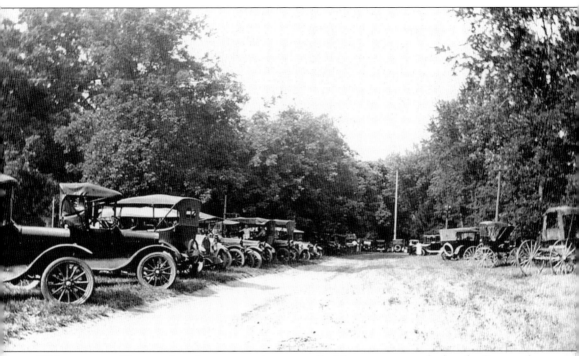

This may seem like a used car lot or an antique car rally. The cars were parked at the Savannah proving grounds while visitors enjoyed the activities of the day. With the accessibility of cars, it was easy for folks of the lead-mining area to visit. Near the Mississippi River in Illinois, the base had been used as a fort during the Black Hawk Uprising. (Courtesy Norene Thompson Pfeil.)

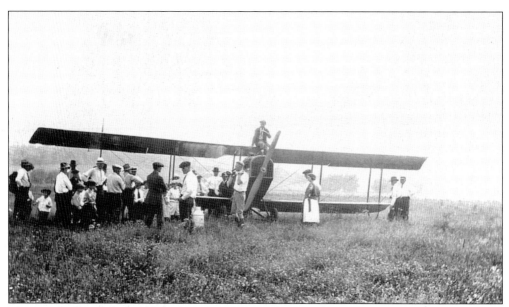

The proving grounds for the army in Savannah, Illinois, allowed visitors to see the planes in the early 1900s. A very large complex, its main purpose was for testing cannons during World War I. The government has kept the property over the years.

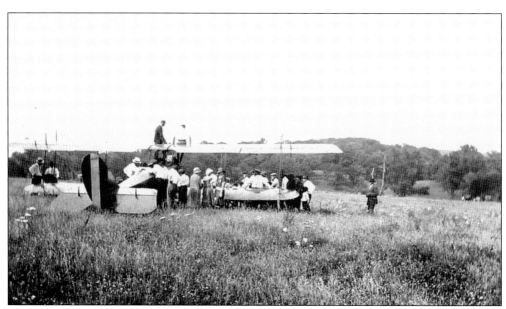

This two-person biplane was a fascination for everyone in the early 1920s. One person even climbed on top of the wings. The flat land was excellent for the takeoffs and landings of new airplanes. (Courtesy Norene Thompson Pfeil.)

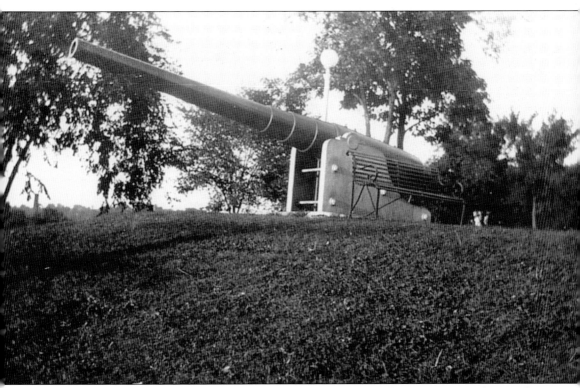

The most important reason for the existence of the Savannah proving grounds was for experimentation with the cannons. The big powerful weapons required a large area. There has not been much activity in recent years, but it is still well maintained by the government. (Courtesy Norene Thompson Pfeil.)

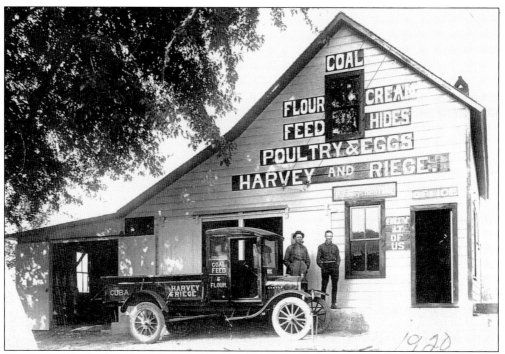

The feed store was an important part of the farming community. Farmers could drive their horses into town to pick up the feed that was not grown on their farm. One might meet his neighbor and have a friendly discussion about weather, crops, and machinery. (Courtesy City of Presidents.)

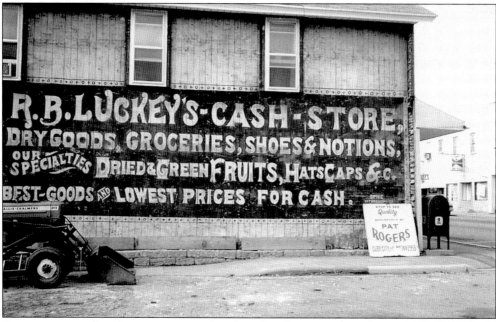

It was common to have large signs painted on the sides of stores, such as this one on R. R. Luckey's. Cash stores were also popular. It indicated that stores could not be expected to extend credit. When the siding was removed, the lettering was still visible. (Courtesy City of Presidents.)

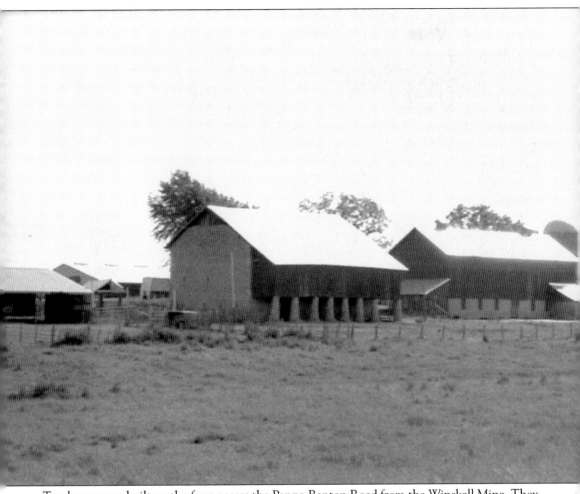

Two barns were built on the farm across the Penna Benton Road from the Winskell Mine. They were unique in structure because of the stone supports on the porte cochere. The house was made of stone and some of the outbuildings had stone foundations. These long-lasting structures remain a tribute to experienced masons from the British Isles.

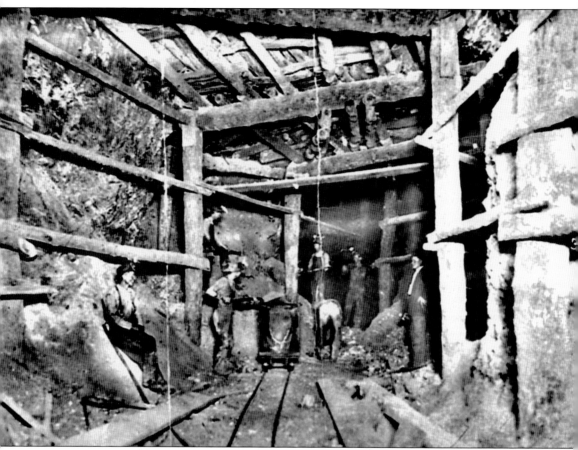

Mules were lowered into mines in strong slings. They stayed considerably long times to move ore carts. Muleskinners took very good care of them. Miners considered the mules part of the working team along with shovelers, blasters, hoistermen, and trimmers.

John and Susannah Howsley March lived in a wood frame house for several years before attaching it to this stone home in the 1850s. The wood part was used as the kitchen, until it was eliminated in the late 1990s. John was a successful farmer and enterprising young man with several patents to his credit.

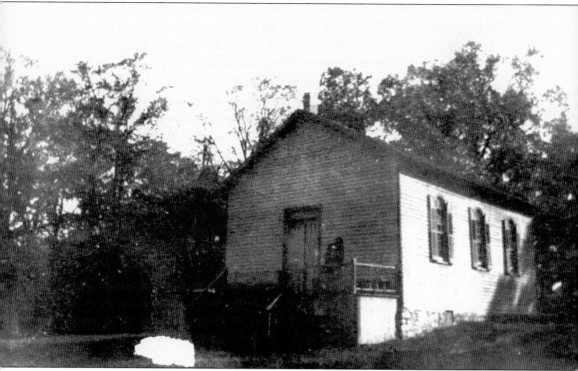

The Monticello Church may have doubled as a school. Thomas Wiley, Lot Dimmick, and Beg Funk were prominent figures in the area. Dick Magoon had a store in Monticello, which served as a stage stop. Stageline horses were kept in his barn. It was said that he met Abraham Lincoln during the Winnebago War. (Courtesy Norene Thompson Pfeil.)

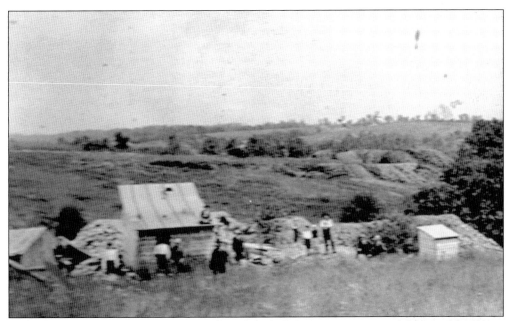

When Col. Henry Gratiot came to the area, he asked Native Americans if they would tell him where lead ore could be found. It seems there was a certain plant called "lead weed" which grew where there was lead. The Native Americans could not divulge their secret but one man shot an arrow in the direction of the lead. (Courtesy Badger Mine Museum.)

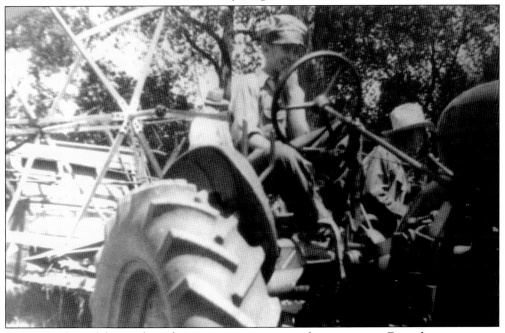

Before the days of the combine, harvesting grain was a multistep process. First, the crop was cut and bound with a binder. Harold Beals drives the Allis Chalmers tractor pulling a McCormick binder. Gerald Temperley (back shown) sits on the seat to control the depth of the blades. Tommy McCarthy walks beside the tractor. Later, families members walked through the field setting the bundles into shocks.

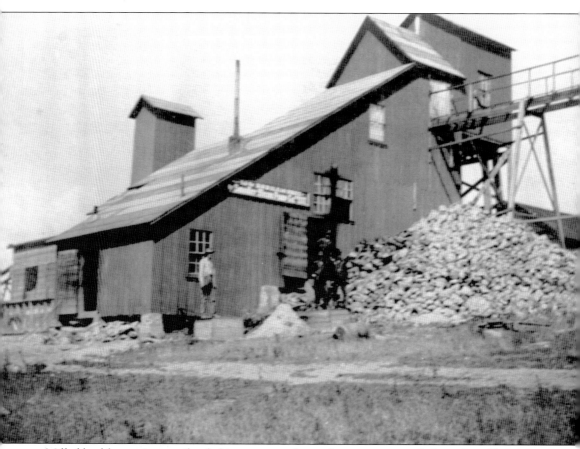

Milled lead from mines was hauled into town on horse-drawn wagons with dump board bottoms. The teamster was the driver of the day. The town had a number of them. Clyde and Emory Hanfield had a large string of teams and wagons in a barn which stood in back of house at 203 North Washington Street in Cuba City. The lead was weighed on the Kivlahan scale and loaded on freight cars for shipment to the smelters. There was no mechanical loader for the job. The teamster got out his shovel and unloaded his wagon. Milled zinc was loaded on freight cars, also then carried to the Linden Zinc plant down the track. (Courtesy Badger Mine Museum.)

Six
Cuba City and Darlington

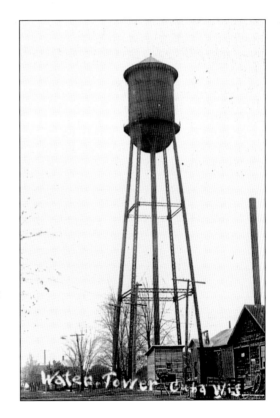

Originally the town pump was on the street in front of the building which housed the post office for many years. In case of fire, men formed a bucket brigade to help each other. A water tower had to be built on the highest point in the town. Cuba City built its tower in March 1827. (Courtesy City of Presidents.)

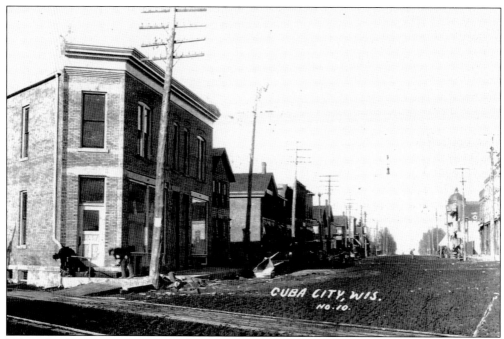

When Stephens, Craiglow, and Johnson laid down a blueprint in 1875 it allowed space for a park. There were 12 original businesses including dressmakers, a millinery store, and a saloon. In 1880, the village of Cuba City had a population of 150. It was not a typical mining town even though there was at least one mine close by. When the Chicago and Northwestern Railroad went through it connected Galena to Elmo. (Courtesy City of Presidents.)

In early times, there was a blacksmith shop on the lot next to the barber shop. The Mitchell brothers, Thomas and William, built the first commercial building on Main Street. William had a wagon shop across the street from Thomas's shop, which was later replaced by a hardware store. The steeple of the Methodist church towers over buildings in the center of the picture, and Delbert Lee's shop is snuggled between two larger buildings. (Courtesy City of Presidents.)

The first retail store was owned by A. G. Schmoll and his wife from Galena. The building, which was on the corner, was later used by Vern's Shoe Store. The Mitchell brothers, Thomas and William, built the first commercial building on Main Street. The brothers later built shops that were replaced by the O'Neill store building and the Cuba City State Bank commercial building. (Courtesy City of Presidents.)

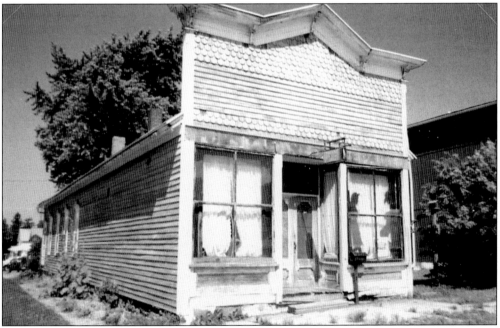

Delbert Lee came here in 1919 and took over the building that had been the Kittoe Drug Store since 1896. He did alterations, shoe shining, and dry cleaning. Delbert is buried in Mount Pleasant Cemetery. The Farmers' Bank took over the bank. In 1910, the name was changed to Cuba City State Bank. (Courtesy City of Presidents.)

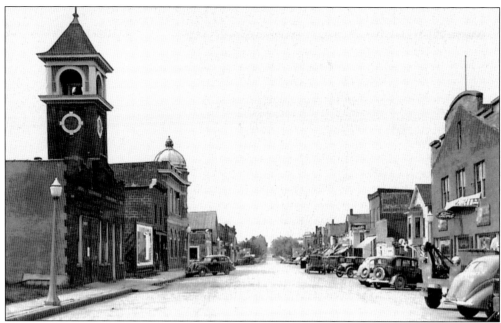

The Northwest Hotel at 100 South Main Street has been home for many businesses over the years. Arthur Brewer bought the lots in 1888. His son Richard and later Richard's two sons, Hayden and Paul, ran the clothing store from 1933 until 1948, when Hayden died. Paul remained in business until 1968. A wrecker is parked in front of George Loeffelholtz's store. (Courtesy City of Presidents.)

George Parker, along with two men from Janesville, formed the Cuba City Improvement Company. They were involved in the Baxter Mine, which was east of town. One of the richer mines, it was a particularly good lead producer. The men bought acreage and subdivided it, adding the several subdivisions to the town. Three streets are named for them. George Parker became the founder of the Parker Pen Company. Palmer was his brother-in-law. (Courtesy City of Presidents.)

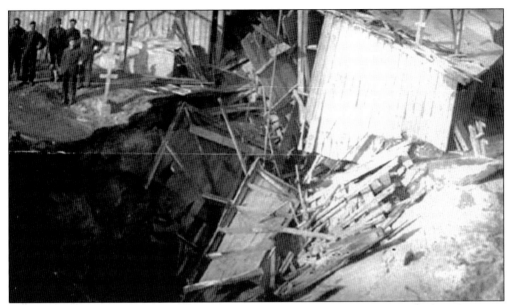

A serious cave-in caused multiple problems at the Baxter Mine in the early 1900s. While no one was killed or injured, the repairs took valuable time from the mining process. Shovelers and other miners had to clean up the debris from the cave-in before work could resume. (Courtesy City of Presidents.)

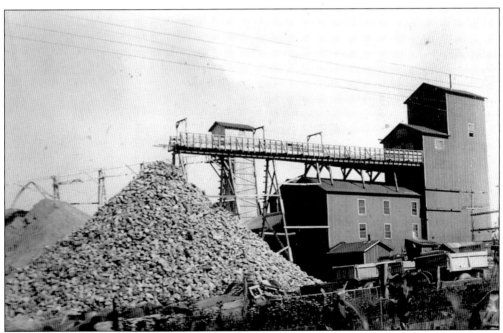

Other mines in the area, like this one near Linden pictured in 1930, included the Great Dividend, Best Midway, Gritty Six, Meeker Grove, Anthony, Dall, Cook, Beacon Hill, CC Lead and Zinc, Henrietta, Roosevelt, Pittsurgh, Rico Eagle, Forcite, Wilkeson, Jerrett Lead and Zinc, Reliable, Little Dick, General Custer, Pine Tree, Lucky Three, and Board of Trade. Power for pumping water and hoisting was supplied by coal-fired steam engines. (Courtesy City of Presidents.)

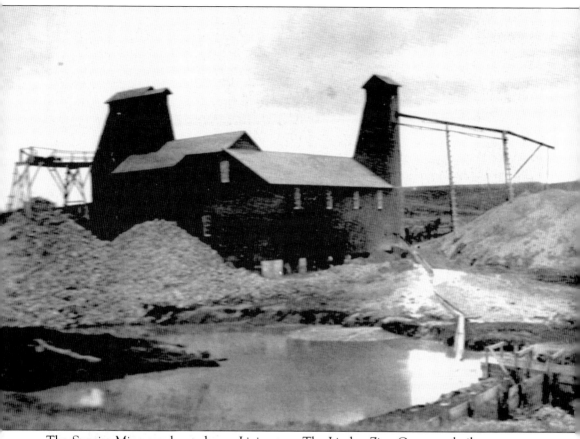

The Sunrise Mine was located near Livingston. The Linden Zinc Company built a roaster at the south end of town which was in operation before World War I and operated until 1948. It was a zinc concentrating plant that used the electromagnetic method for separating zinc from rocks. Even though it was bad for the environment, it was Cuba City's biggest and longest-lasting industry. (Courtesy City of Presidents.)

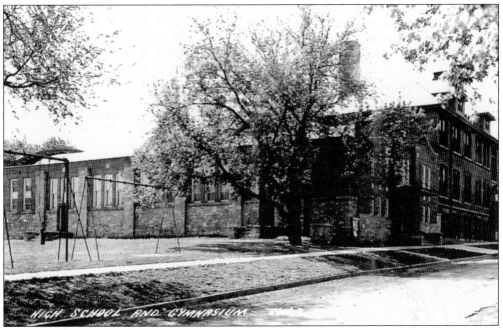

Commonly known as the pit, the old high school gymnasium has been the scene of many school and community activities. Because Cuba City supports organized sports of all kinds and has had many volunteers to do the coaching, there has always been a need for extra places to practice.

In 1934, the height of the Great Depression, local people provided the manpower to build a band shell in the park. Government funds were used to give these people productive, worthwhile work. The stage platform in front has since been torn down. (Courtesy City of Presidents.)

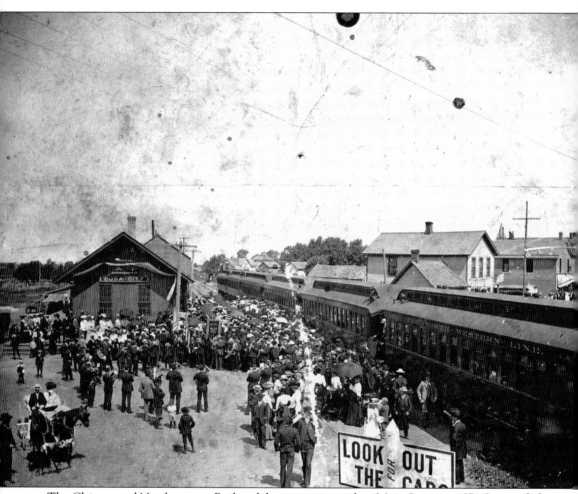

The Chicago and Northwestern Railroad depot was situated on Main Street in 1874. It provided passenger service, which was a flatcar furnished with plank benches. It was adequate in pleasant weather but not suited for people in inclement weather. The route consisted of two daily trips to Elmo and two back to Galena. On this occasion, folks turned out to welcome returning veterans. (Courtesy City of Presidents.)

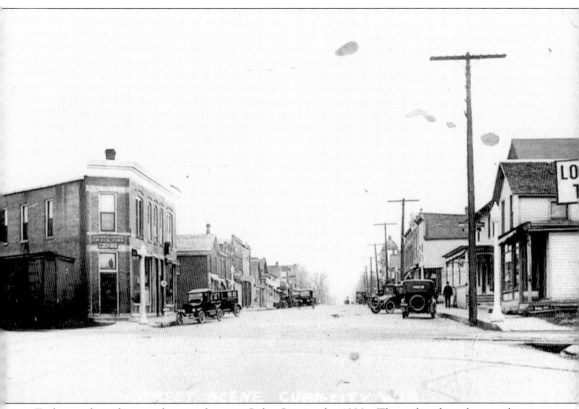

Early cars line the paved streets here in Cuba City in the 1920s. The railroad tracks ran along the side of the triangular building which housed the post office. The steepled building and the dome on the First National Bank are visible. White electric light poles had been installed on intersections of the modern streets with sidewalks.

George Loeffelholz ran a plumbing and heating business for many years. Eventually he sold the business to Douglas and Bruce Hilvers. Loeffelholz was the mayor from 1940 to 1946 and also owned shares of the Cuba City State Bank. In 1917, he and his brother Charles, along with John B. Wagner, formed Loeffelholz Brothers and Wagner in the old village opera house. George was in charge of the repair department. The second story was used as a dance hall and later as a skating rink. (Courtesy City of Presidents.)

Another opera house was a one-story building with plank seats and a stove. It was used for high school graduations, talent shows, and traveling troupes. Moving pictures were shown there. It became a garage in 1915. Gilbert Skelding and Henry Kellner bought the Marshall Building in 1934, remodeled it, and began Cuba Theater. It was later sold to Leo Gohlmann, who stayed in business until 1973. (Courtesy City of Presidents.)

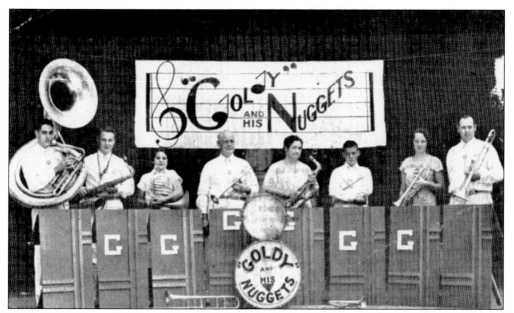

Goldy Goldthorpe taught at the high school in the 1930s and 1940s. He founded the Tri-Couty Press and operated it for many years. The members of the band are Byron Willey (tuba) and family members Rex (saxophone), Golden Bryant (French horn), William (trumpet), Ina (saxophone), Glenn (saxophone), Dorothy Clemens (trumpet), and Byron (trumpet). (Courtesy City of Presidents.)

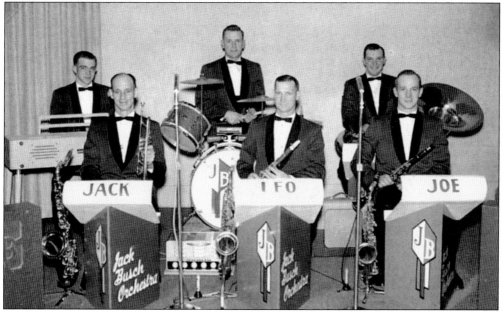

The Jack Busch Orchestra was a popular dance group in the 1950s and 1960s. From left to right are (first row) Jack Busch, Leo Busch, and Joseph Busch; (second row) Frank, Arnold, and Robert Busch. The next generation of Busch members, Larry and Marty, continued with the orchestra for many years. Their children and grandchildren still have musical groups. (Courtesy City of Presidents.)

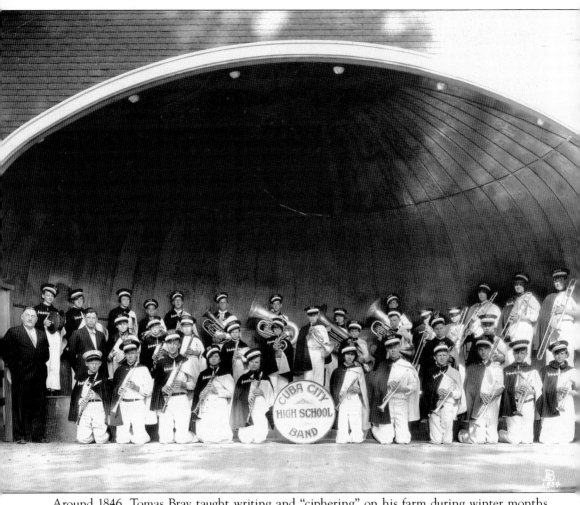

Around 1846, Tomas Bray taught writing and "ciphering" on his farm during winter months only—to boys only. The first school board consisted of Solomon Craiglow, Thomas Bray, and Isaac Nicholas. The old redbrick school was replaced in 1876 by a frame building. In addition to the sports program, Cuba City excels in its music department. Pictured here is the 1934 Cuba City High School band in the band shell. (Courtesy City of Presidents.)

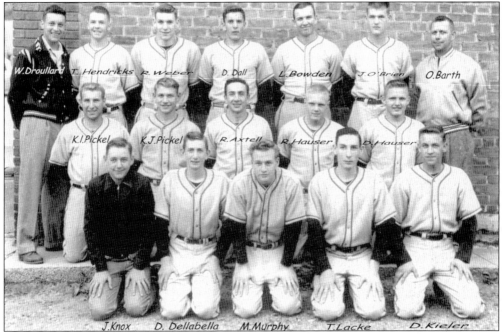

Cuba City has a long tradition of winning teams, beginning when volunteers coached basketball and football. There were not enough complete uniforms so team members had to share as subs were put into the game. Herman L. Jacobson, attorney Bill Murphy, and Frank C. Florine served as coaches. The winners in 1921 and 1923 were the first in a long line of state basketball teams. Seen here is the 1955 baseball team, runners up in the state. In the 1990s, both the girls and boys teams won state championships. (Courtesy City of Presidents.)

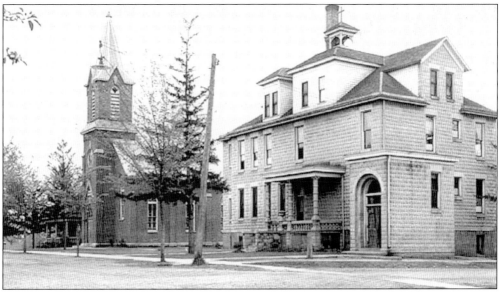

St. Rose of the Priarie was indeed built on the prairie or as one old-timer said, "way out in a cornfield." Fr. Samuel Mazzuchelli established the congregation and inspired members to raise funds and proceed with construction. This picture shows the school also, and later a parsonage was put to use. (Courtesy City of Presidents.)

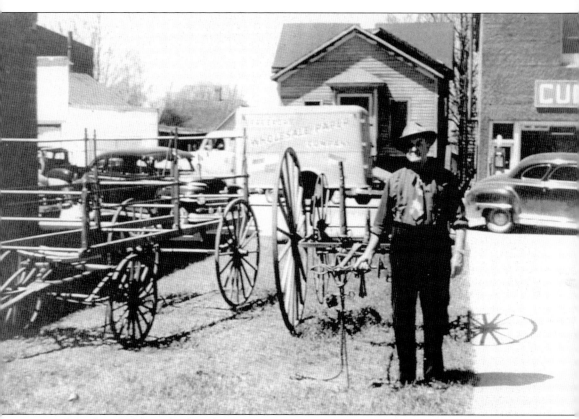

An unidentified man displays the equipment of the fire department in front of the Wholesale Paper Company in the 1940s. The cart, with its long-tongued hand grips and narrow wheels, was probably pulled by men along the muddy streets. The gas pumps indicate that the horse-drawn vehicles were on their way out. (Courtesy City of Presidents.)

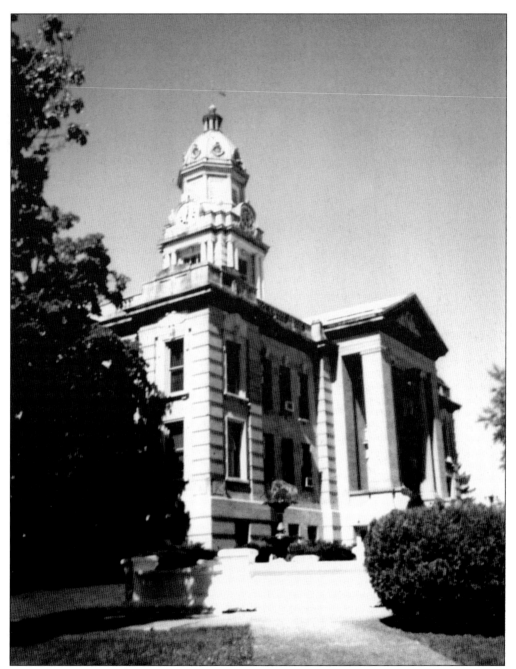

Until the 1960s, eighth-grade graduates from all the rural schools had a picture taken on these courthouse steps. Matthew Murphy, whose family struck it rich when they settled in Leadmine, donated all the money for the courthouse. His brother Dennis furnished land for three different churches in Benton. The county seat was moved from Shullsburg to Darlington in 1861 in spite of those who wanted it to remain in Shullsburg. The impressive building with vast columnar supports on the portico has remained a source of pride for generations of county residents. It has been remodeled several times and now is crowned by a domed steeple. (Courtesy Lafayette County Historical Society.)

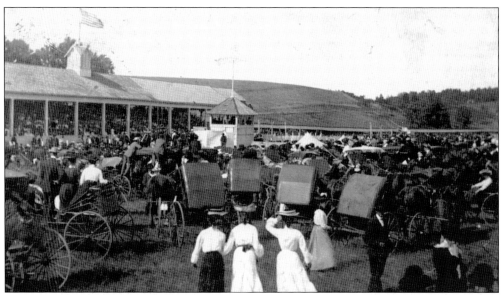

Horse racing was popular at the Lafayette County Fair, as shown by the crowd in the grandstand. In the early days, families brought a picnic lunch to enjoy the races and farm-related exhibits. Someone had to water the carriage horse during the day. Being close to the Pecatonica River, the fairground was always susceptible to flooding. (Courtesy Lafayette County Historical Society.)

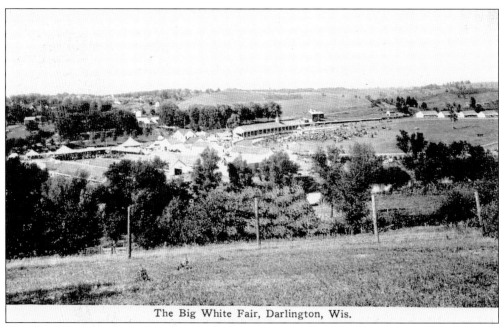

The Big White Fair, Darlington, Wis.

The "Big White Fair" may have been called this because all the buildings were white or it may have been a reflection of the Columbian Exposition in 1893. Established as the Lafayette County Fair, it has served 4-H and FFA groups for many years. County rural school students showed their work there.

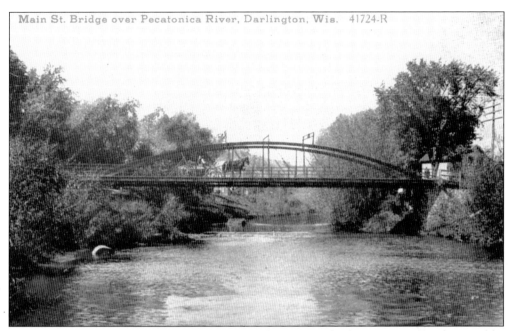

The first bridge over the Pecatonica River in Darlington was built in 1856. It was destroyed by flood. The arched iron bridge was built in 1877. The bridge that was built in 1918 was torn down and replaced in 1968. A postcard from 1929 showed the Chevy Garage, which stayed in business until 1980 in spite of frequent flooding. (Courtesy Lafayette County Historical Society.)

The little people who lived in the Cornish tin mines were called tommy knockers. They were as tall as two feet with long legs and knobby knees. They wore tin hats and leather aprons. Tommy Knockers played tricks on the miners, like blowing out their candles and hiding their tools. Presumably the sound of their wee picks could be heard coming from deep in the mines every day except Sunday. Then the sound of singing came forth.

Across America, People are Discovering Something Wonderful. Their Heritage.

Arcadia Publishing is the leading local history publisher in the United States. With more than 3,000 titles in print and hundreds of new titles released every year, Arcadia has extensive specialized experience chronicling the history of communities and celebrating America's hidden stories, bringing to life the people, places, and events from the past. To discover the history of other communities across the nation, please visit:

www.arcadiapublishing.com

Customized search tools allow you to find regional history books about the town where you grew up, the cities where your friends and family live, the town where your parents met, or even that retirement spot you've been dreaming about.